Nostalgia Is A Liar

Saniya Rao

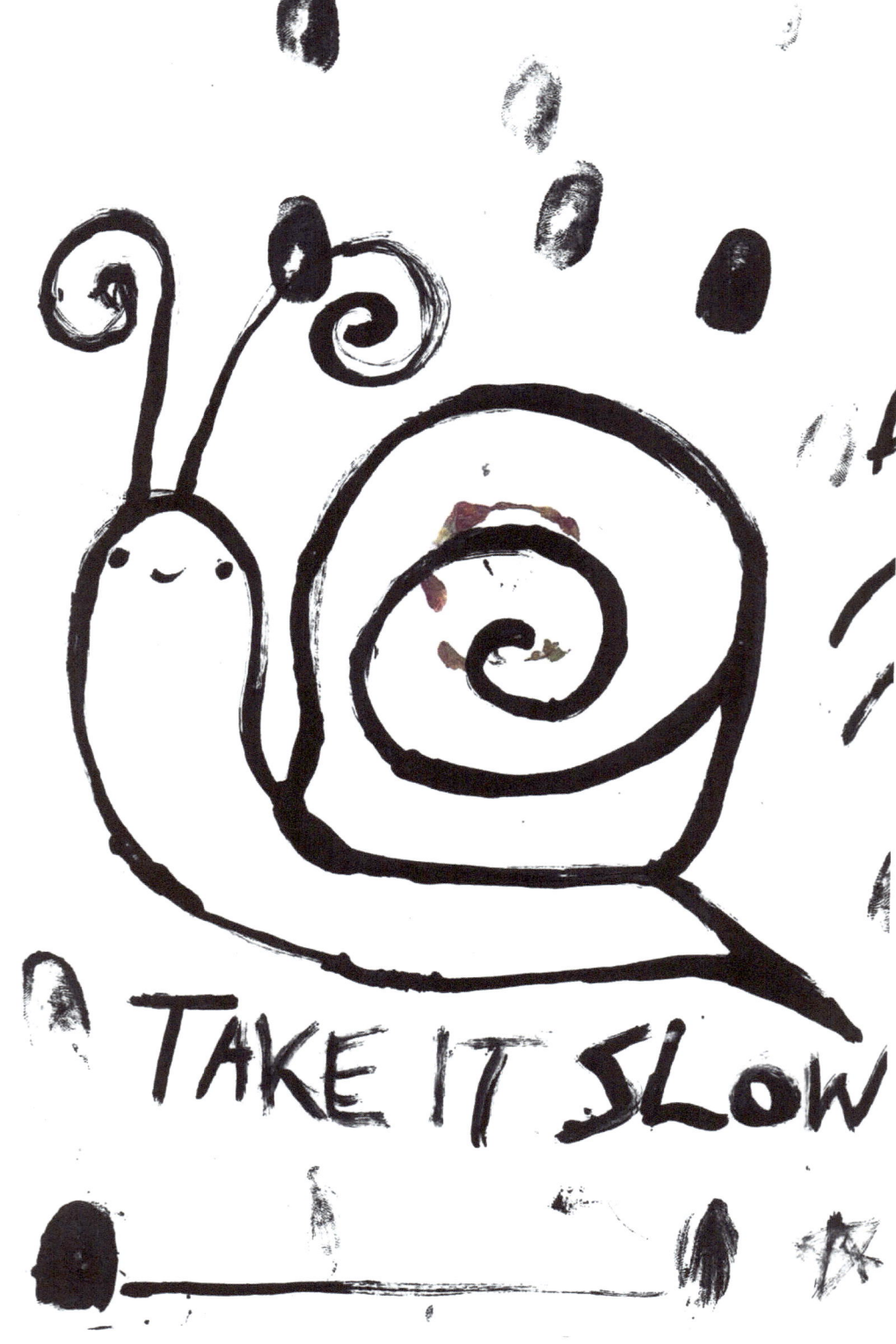

SHOUT OUT
Vasu
Derron and Harry
Dorothy
Prabhu
Roshni
Peter
Chris
Victoria
David
Harry Jr.
Brian
India
Iman
Mikayla
Madison
Izayah
Antoinette
Quincy
Cira
Alex and Dijohn
Shua
and Glen

Also Mr.Hardy, Mr.Brandhorst, Ms.Williams, and Ms.Wadsworth

Thank You God. I love you Mom and Dad.
R.I.P Terry Hawk

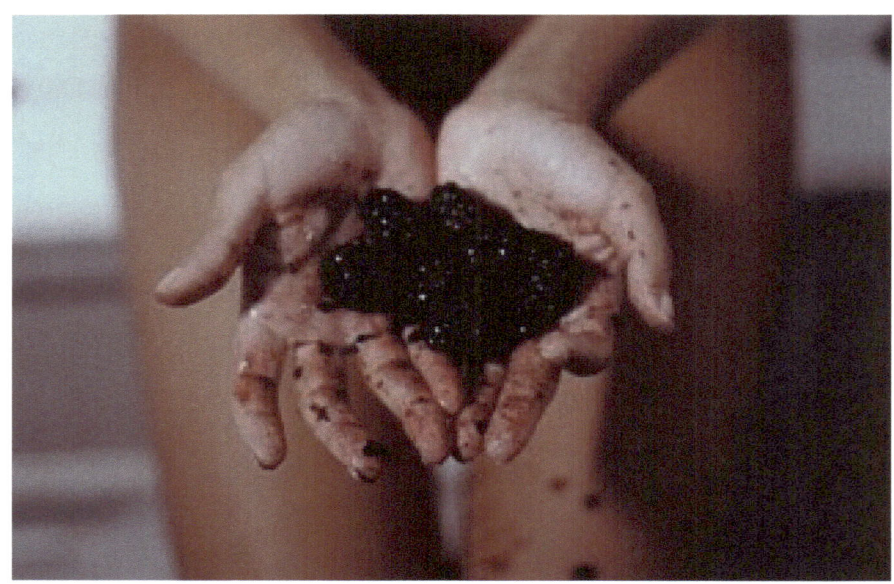
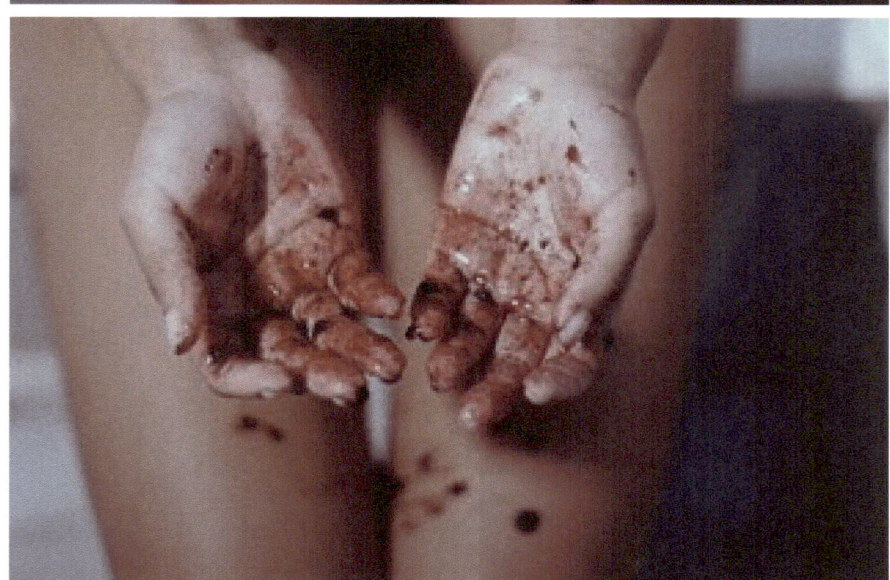

Young Blood

sublimity and savagery
experience the yin yang of the desire
to keep changing into the future
the world might seem odd
but...you can't give up

that mixture of poetry and pain is typical
of the results of a life lived
the human life in its fullness
hungry for jazz,poetry,and transcendentalism

right now we're in such a dark place
such a troubled place
strays, wanderers looking for a journey
thinking of language and deeper connections

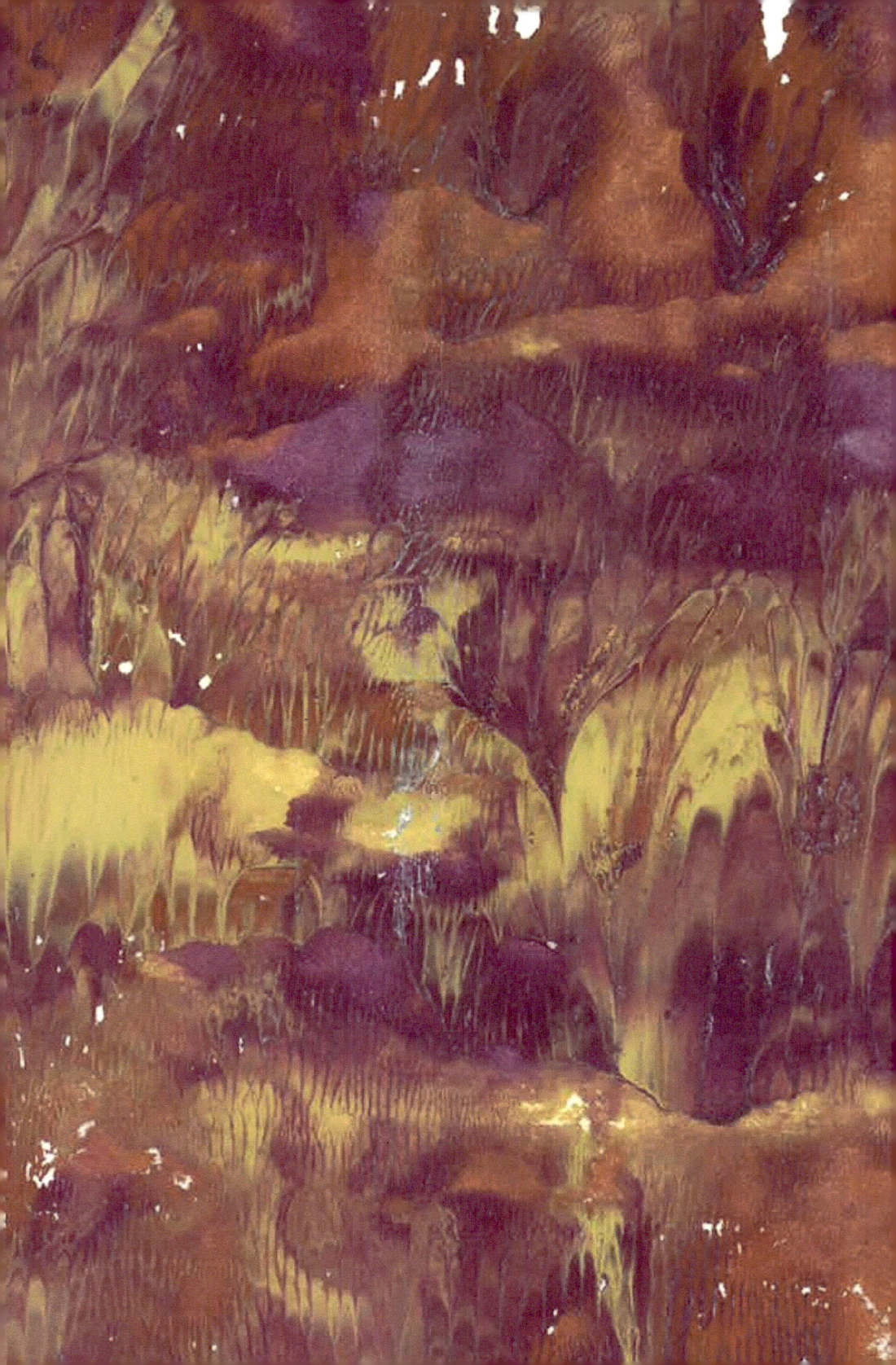

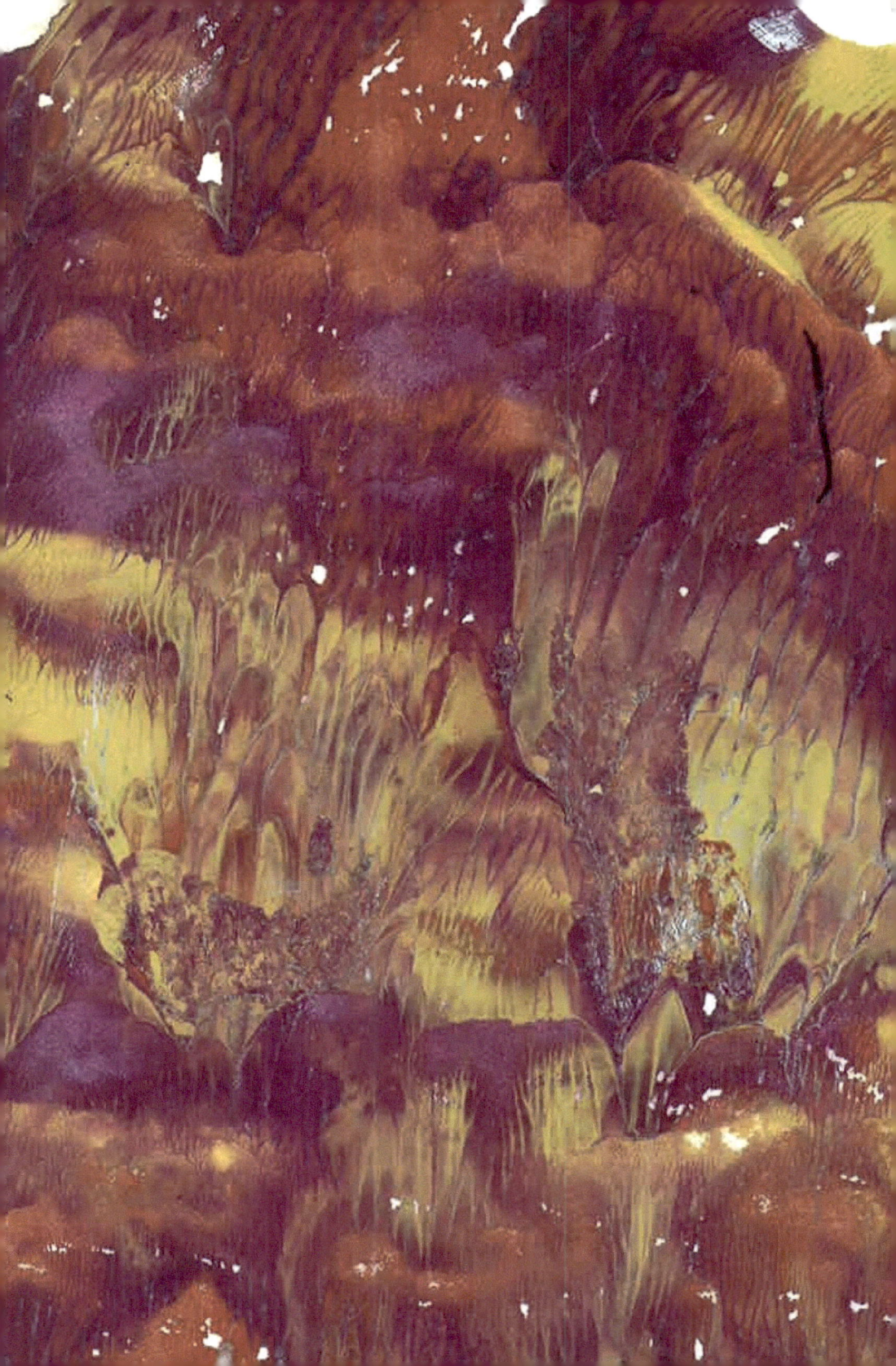

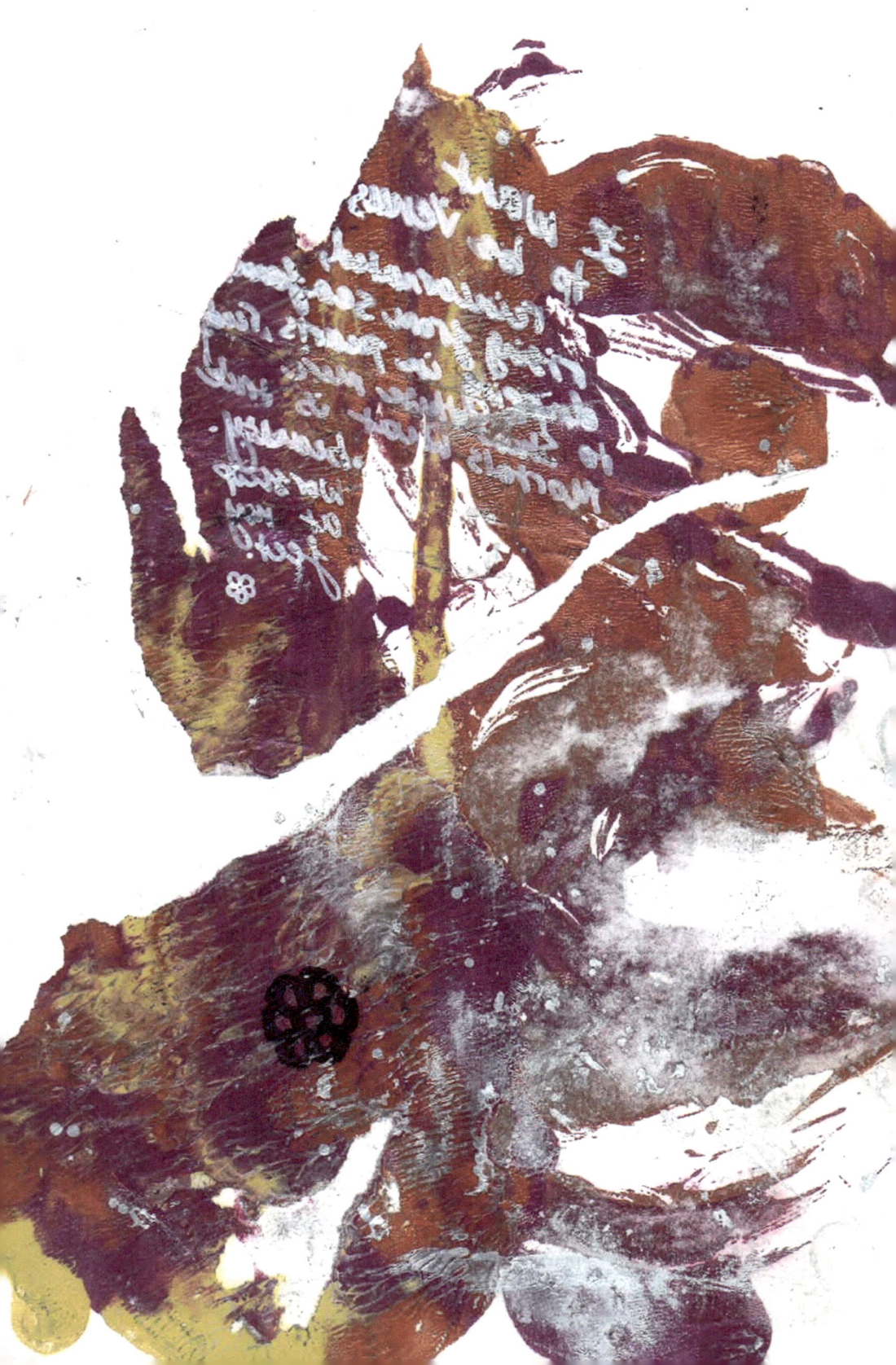

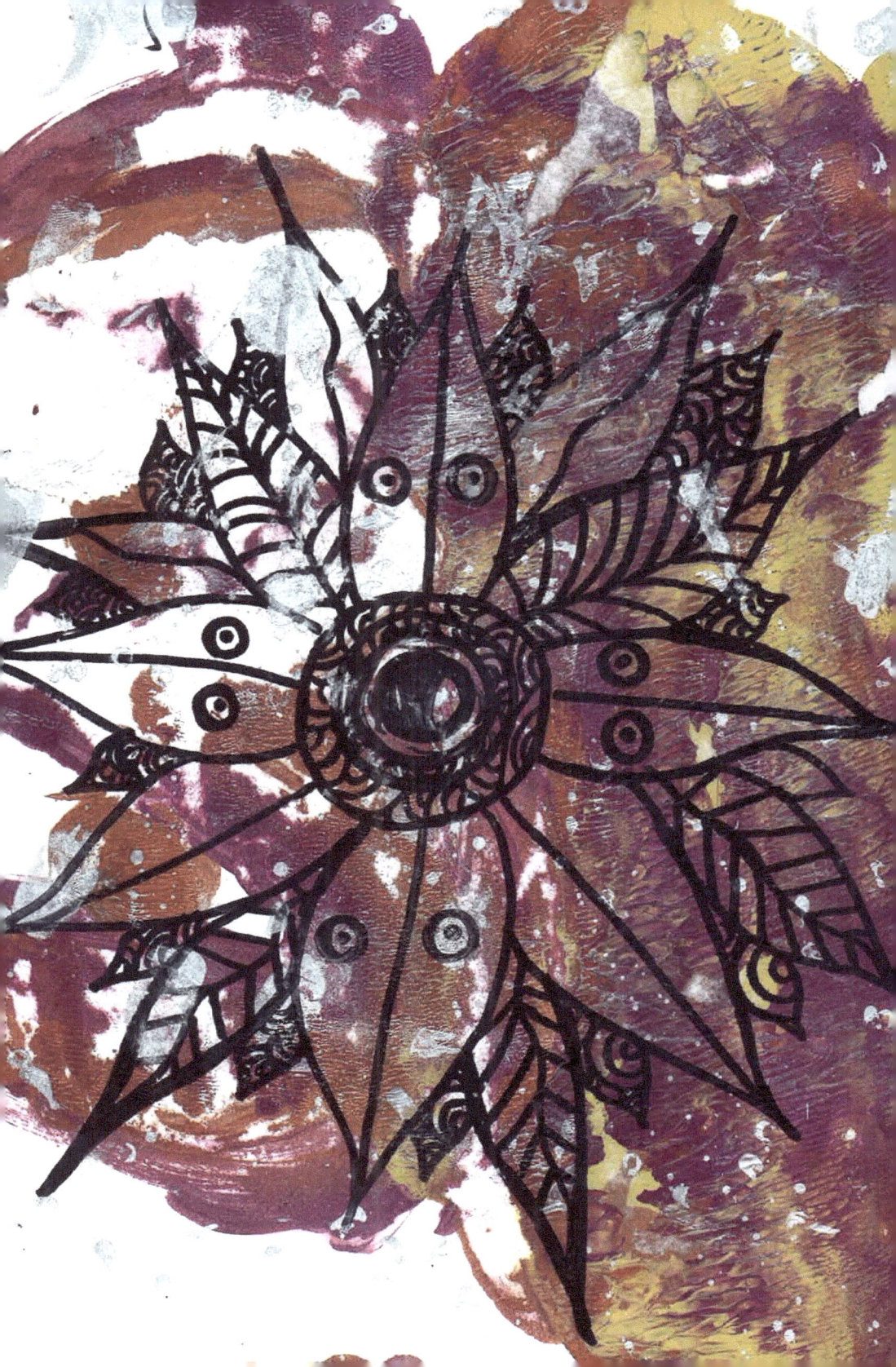

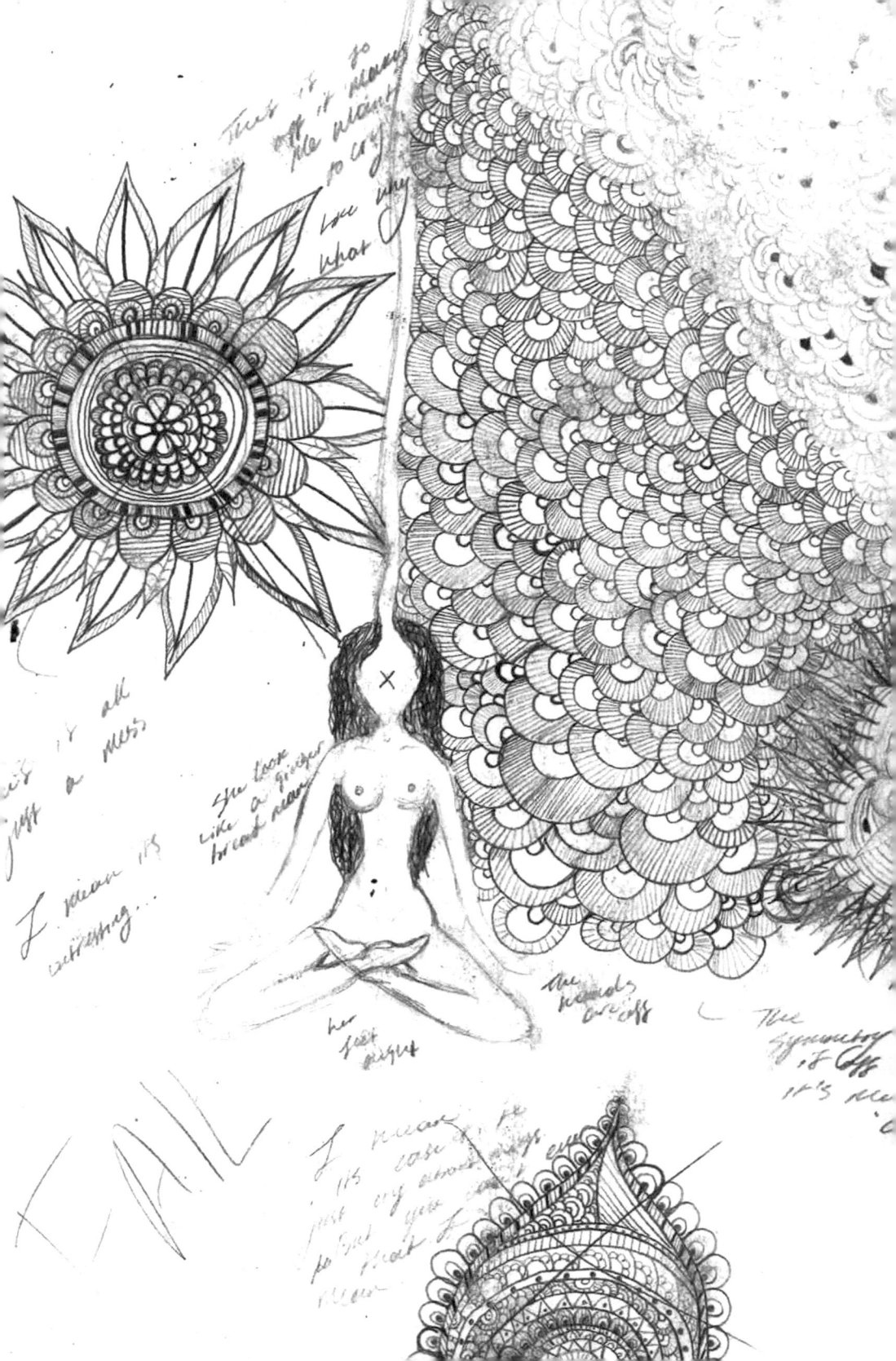

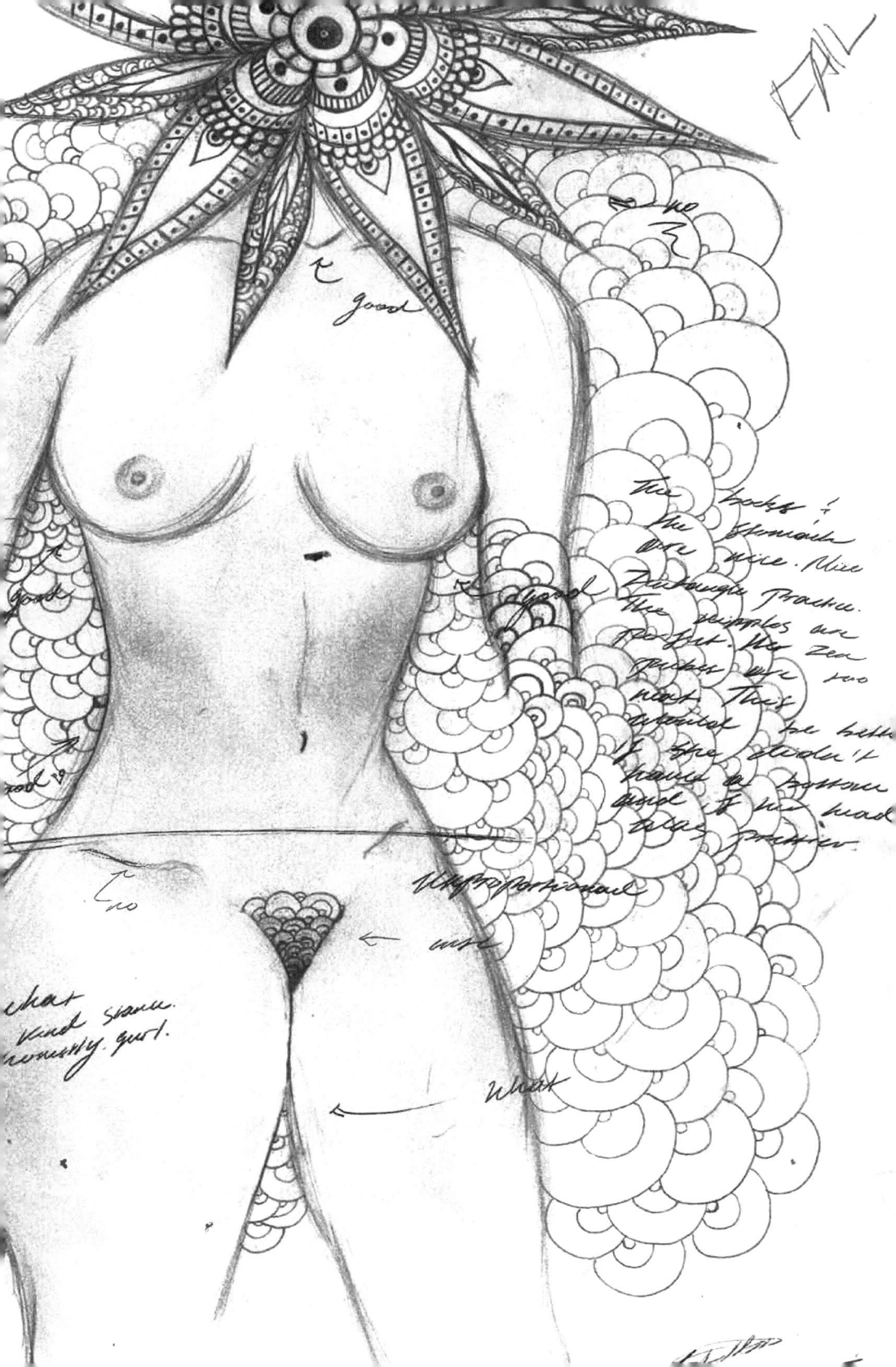

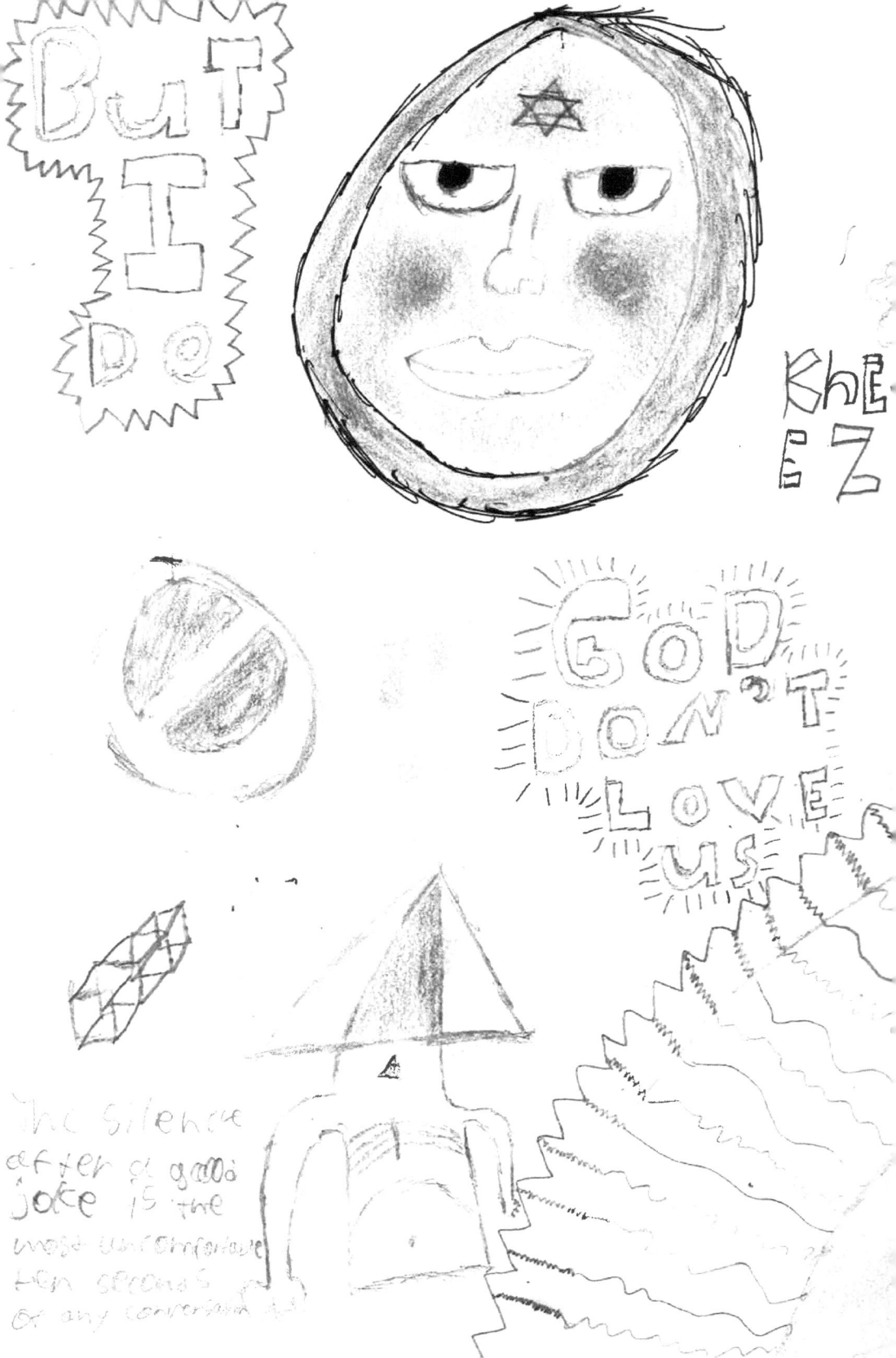

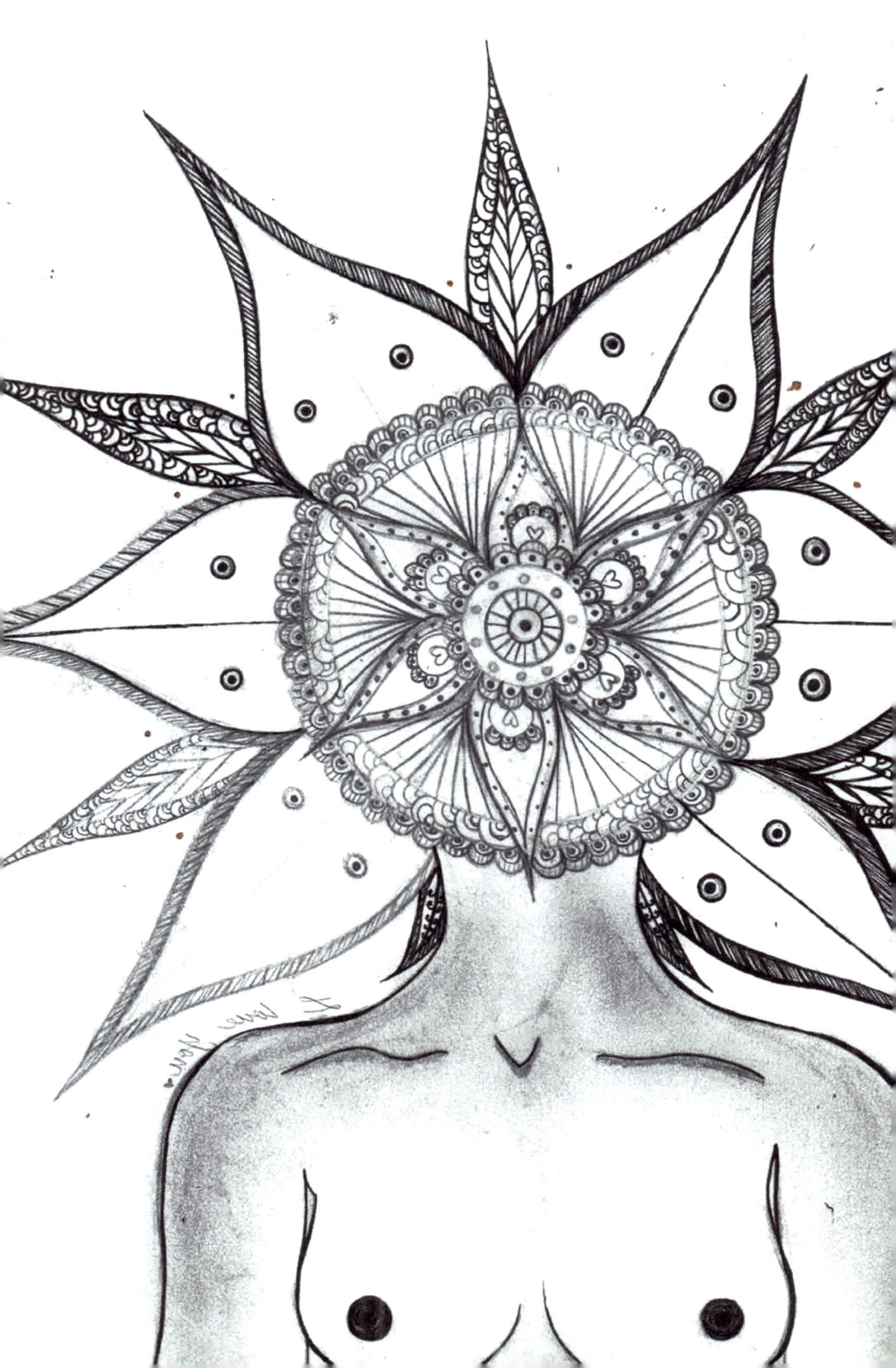

You know you fucked up when you can't see the way you look without a mirror. That is because you don't know who you are anymore. You can not identify yourself.

Love, Love

Tropicana

100

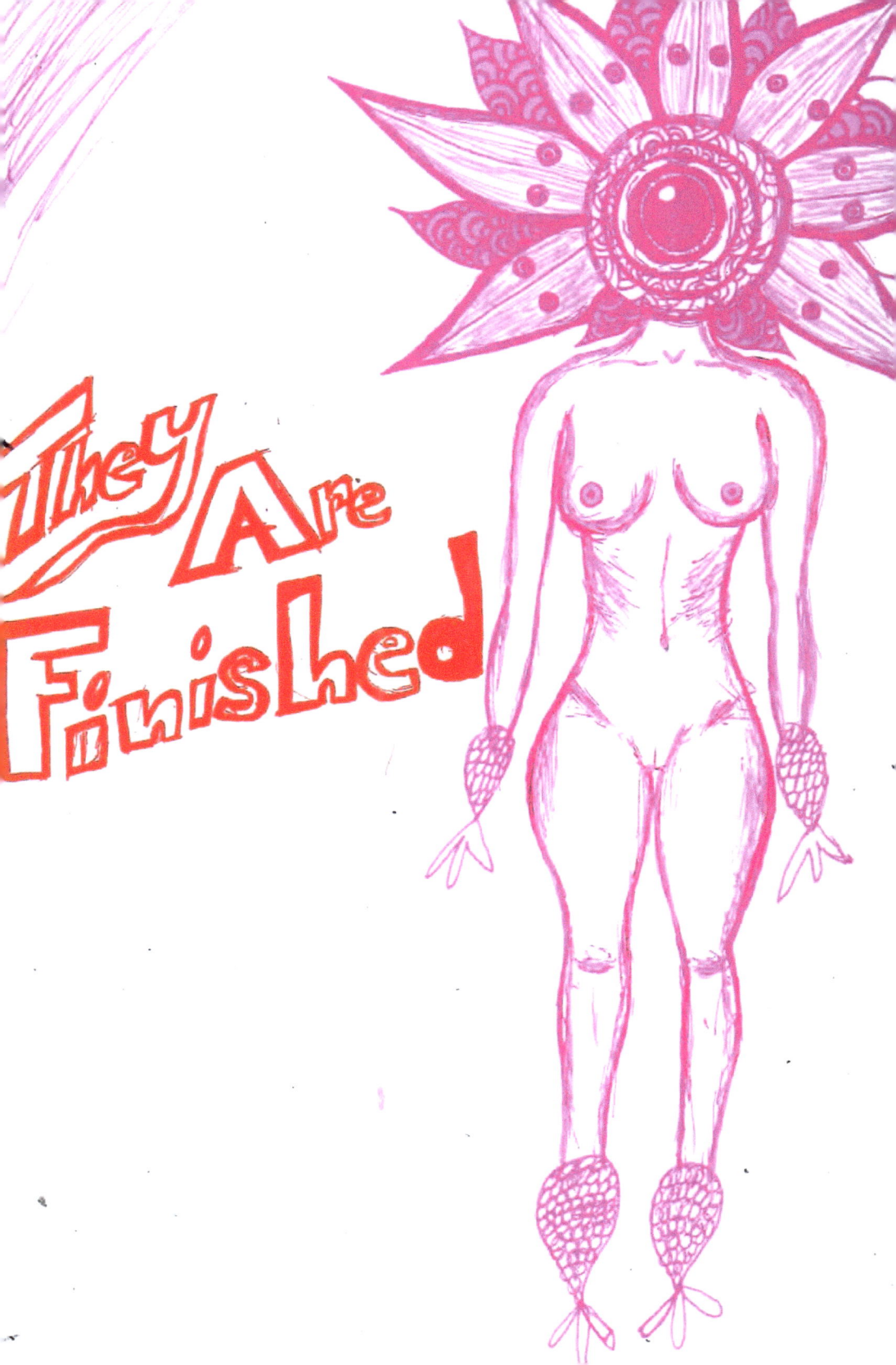

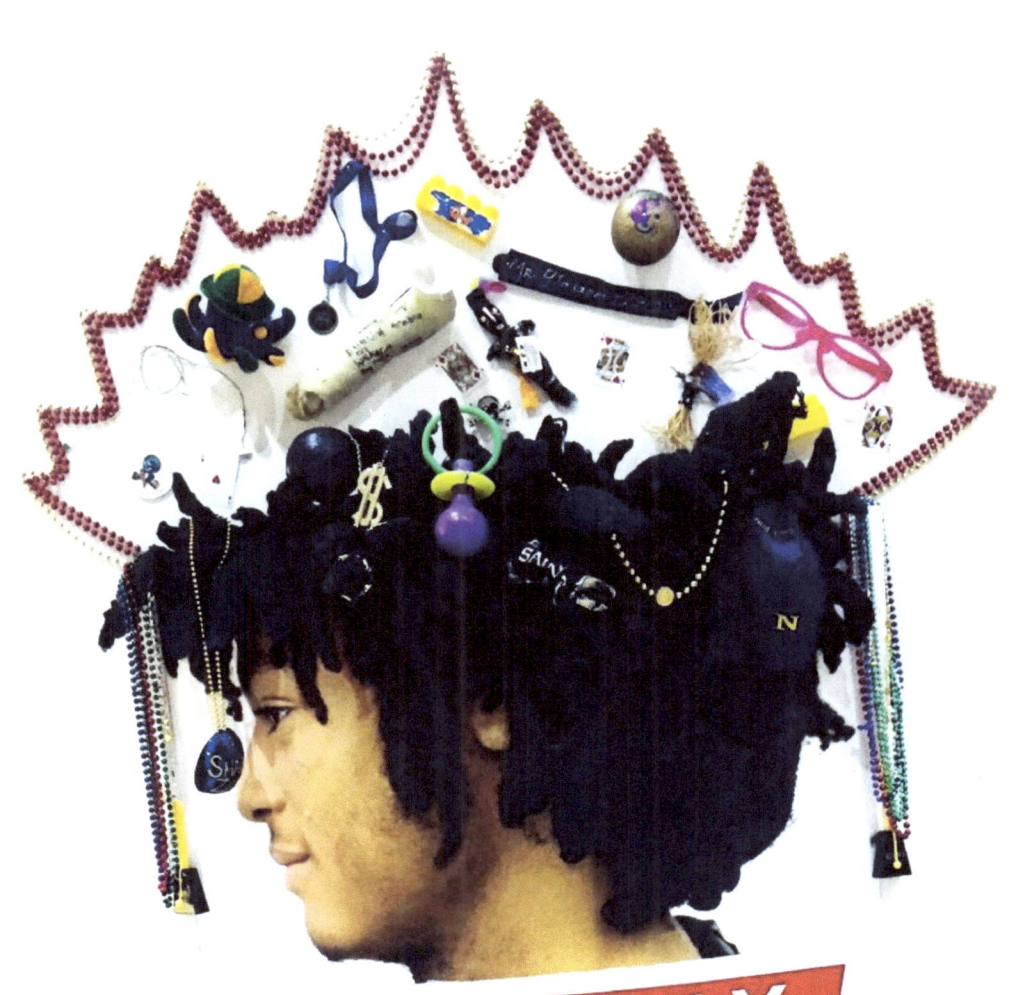

...and their own insecurities, limitations, and needs, and you don't have to internalize that. You exist, both that isn't contingent upon other people's acceptance of you, it's something inherent. You exist, and therefore you matter. You're allowed to voice your thoughts and feelings & take up space. You're allowed to assert your needs and hold onto the truth that who you are is exactly enough. And someone in your life who makes you feel otherwise, or whose affection or approval is contingent upon you, or who rejects or abandons or judges you, it isn't really about you. It's about them and their own insecurities, limitations, and needs, and you don't have to internalize that. Your worth isn't contingent upon other people's acceptance of you, it's something inherent. You exist, and therefore you matter. You're allowed to voice your thoughts and feelings & take up space. You're allowed to hold onto the truth of who you are is exactly enough. And You're a—

"When I heard the learn'd astronomer; When the proofs, the figures, were ranged in columns before me; When I was shown the charts and the diagrams, to add, divide, and measure them; When I, sitting, heard the astronomer, where he lectured with much applause in the lecture-room, How soon, unaccountable, I became tired and sick; Till rising and gliding out, I wander'd off by myself, In the mystical moist night-air, and from time to time, Look'd up in perfect silence at the stars."

...anyone's affection or approval to be good enough. When someone rejects or judges you, it isn't about you. It's about them and their own insecurities, limitations, and needs. And you don't have to internalize that. Your worth isn't contingent upon other people's acceptance of you, it's something inherent. You exist...

Stella
04-30-15

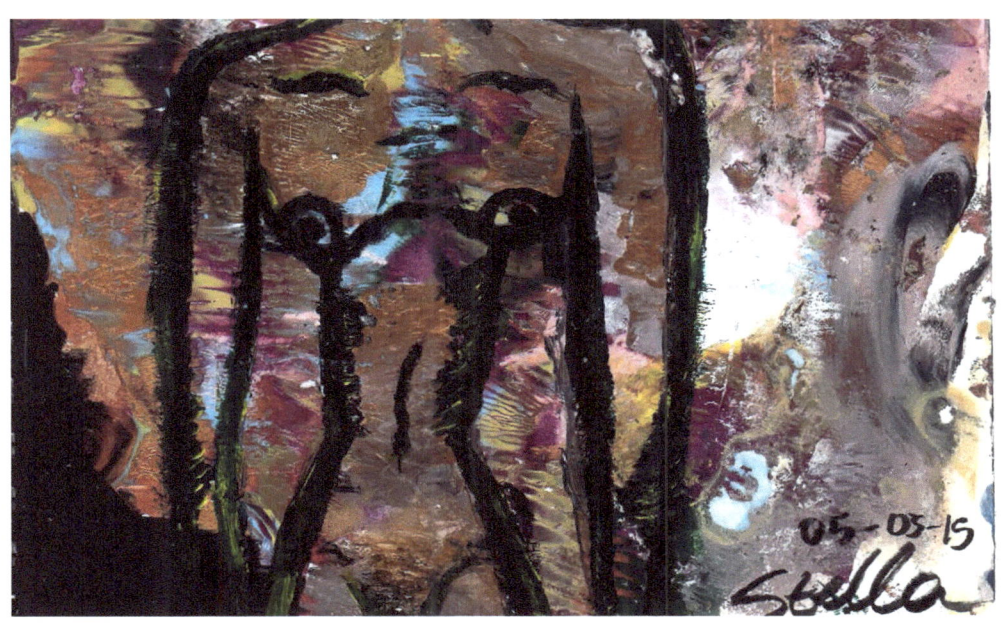

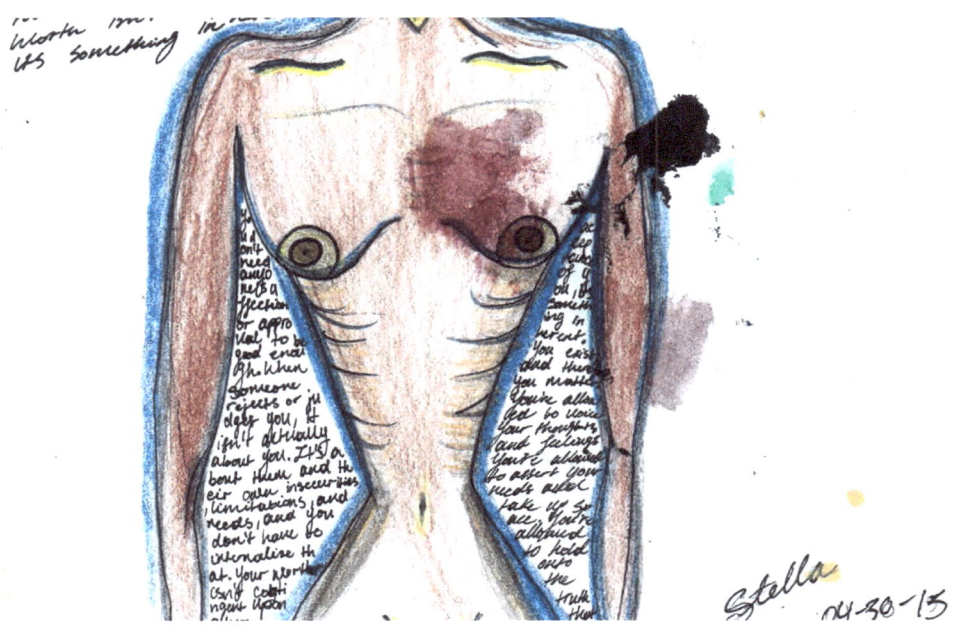

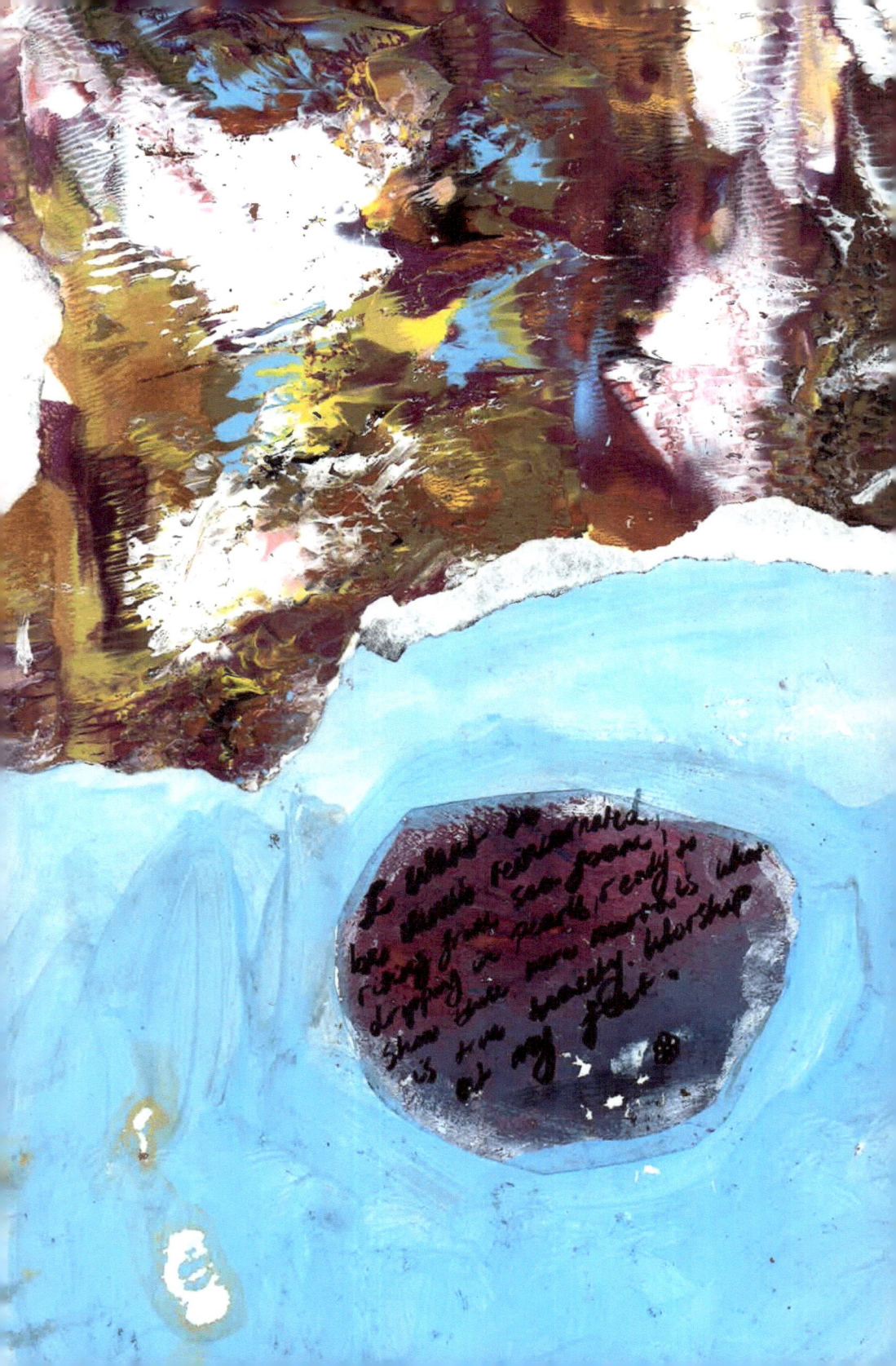

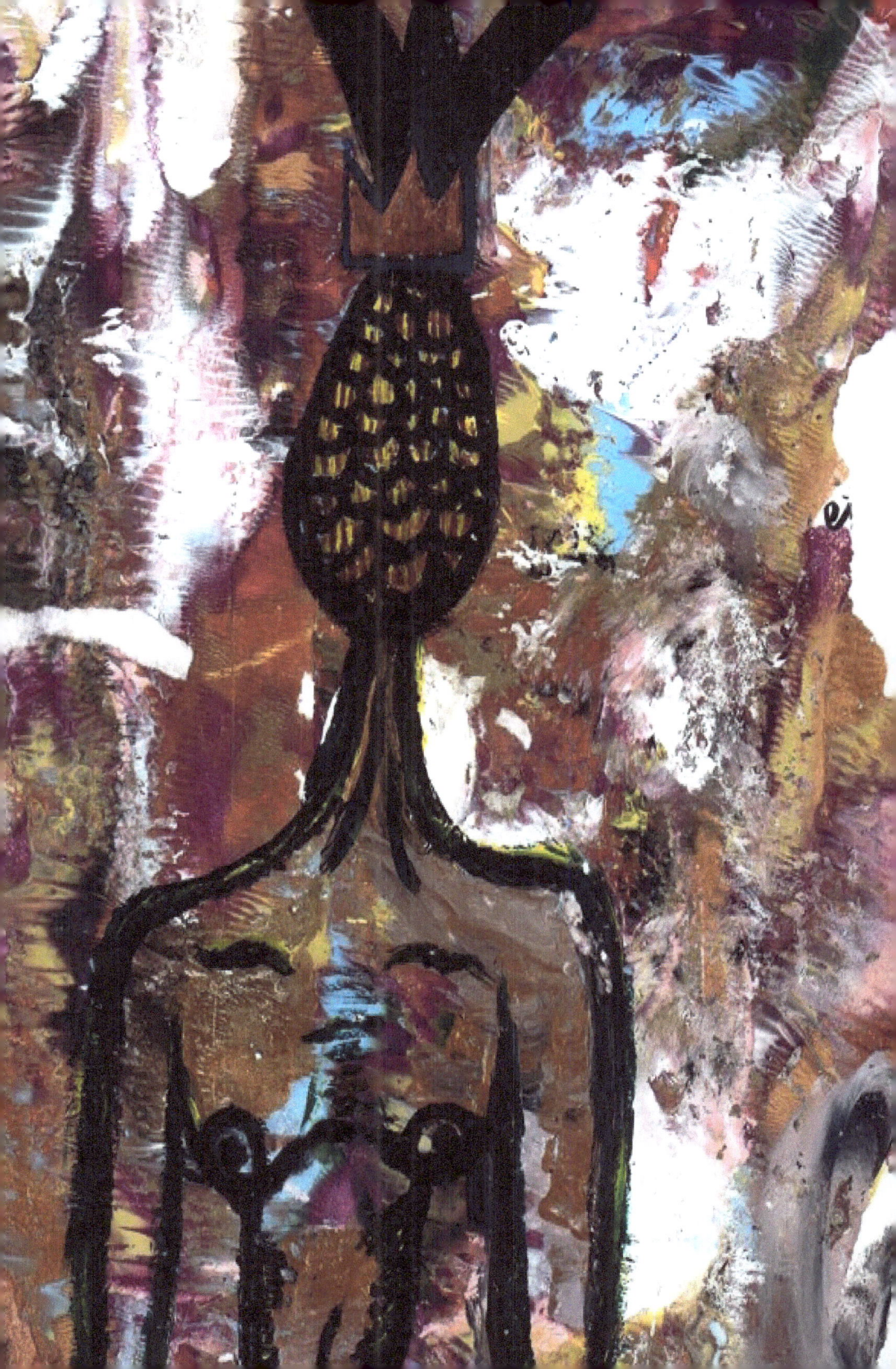

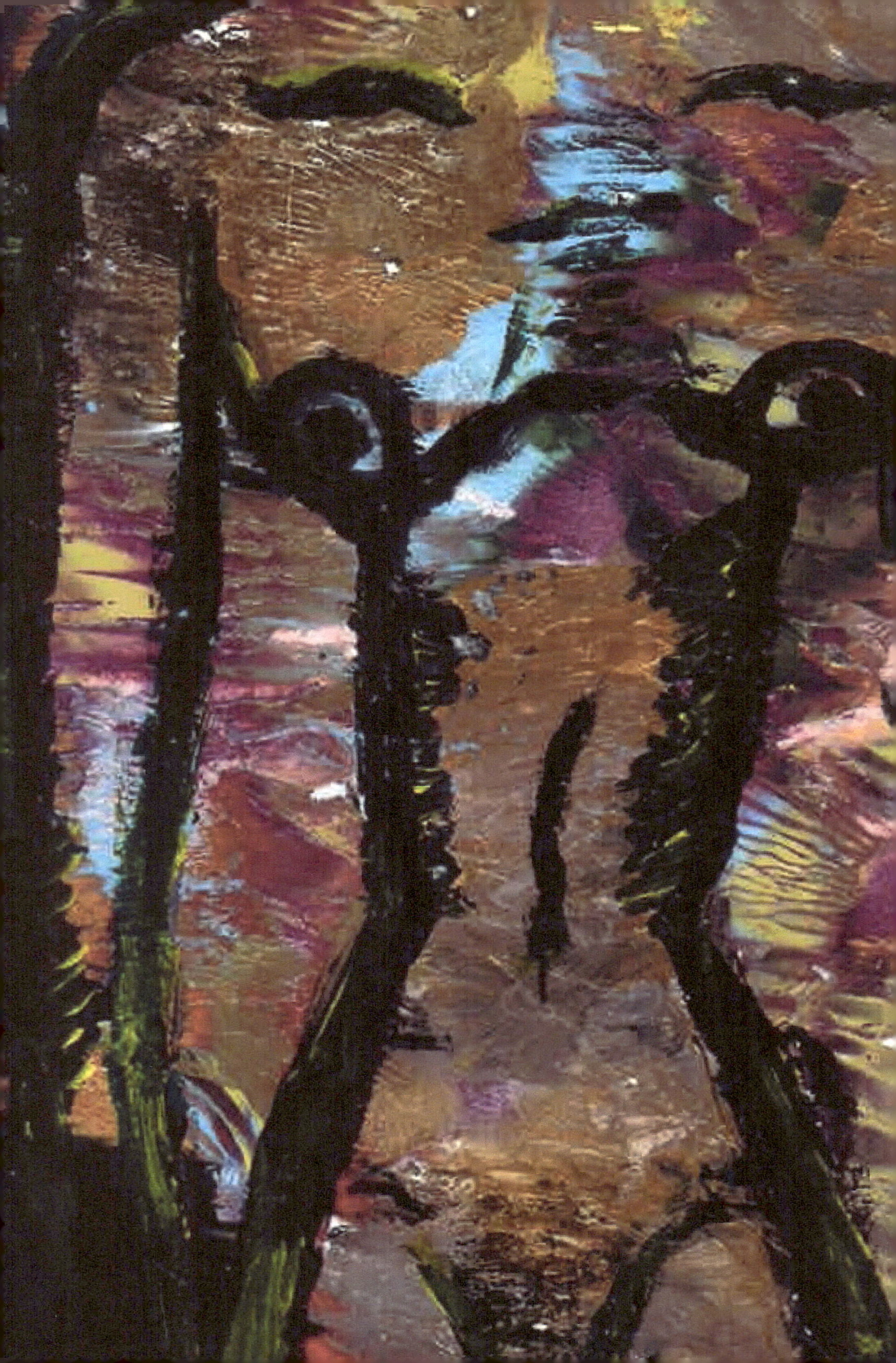

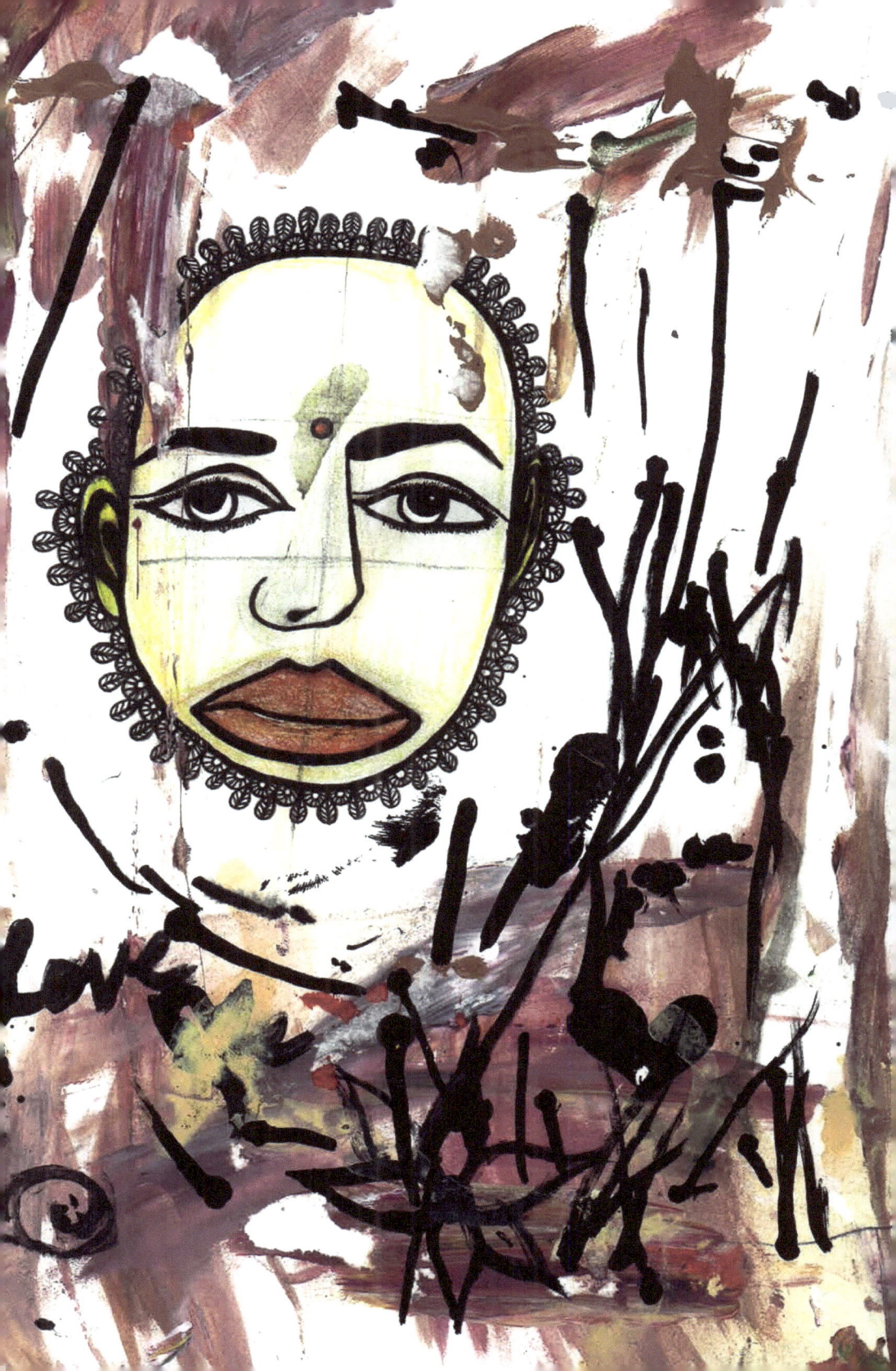

I like to draw ~~exchange~~
~~thick~~ big lips

(ME ON A GOOD DAY)
WITH HENNA ON
MY HANDS

A poet by nature,

littered with the detritus of drug abuse.

look away

DO A SERIES OF SELF PORTRAITS WHERE YOU ARE NOT FULLY HUMAN (cause u not expose yourself)

YOU KNOW YOU ARE A TOXIC ROMANTIC WHEN YOUR LIFE HAS BECOME TOO MANY METAPHORS

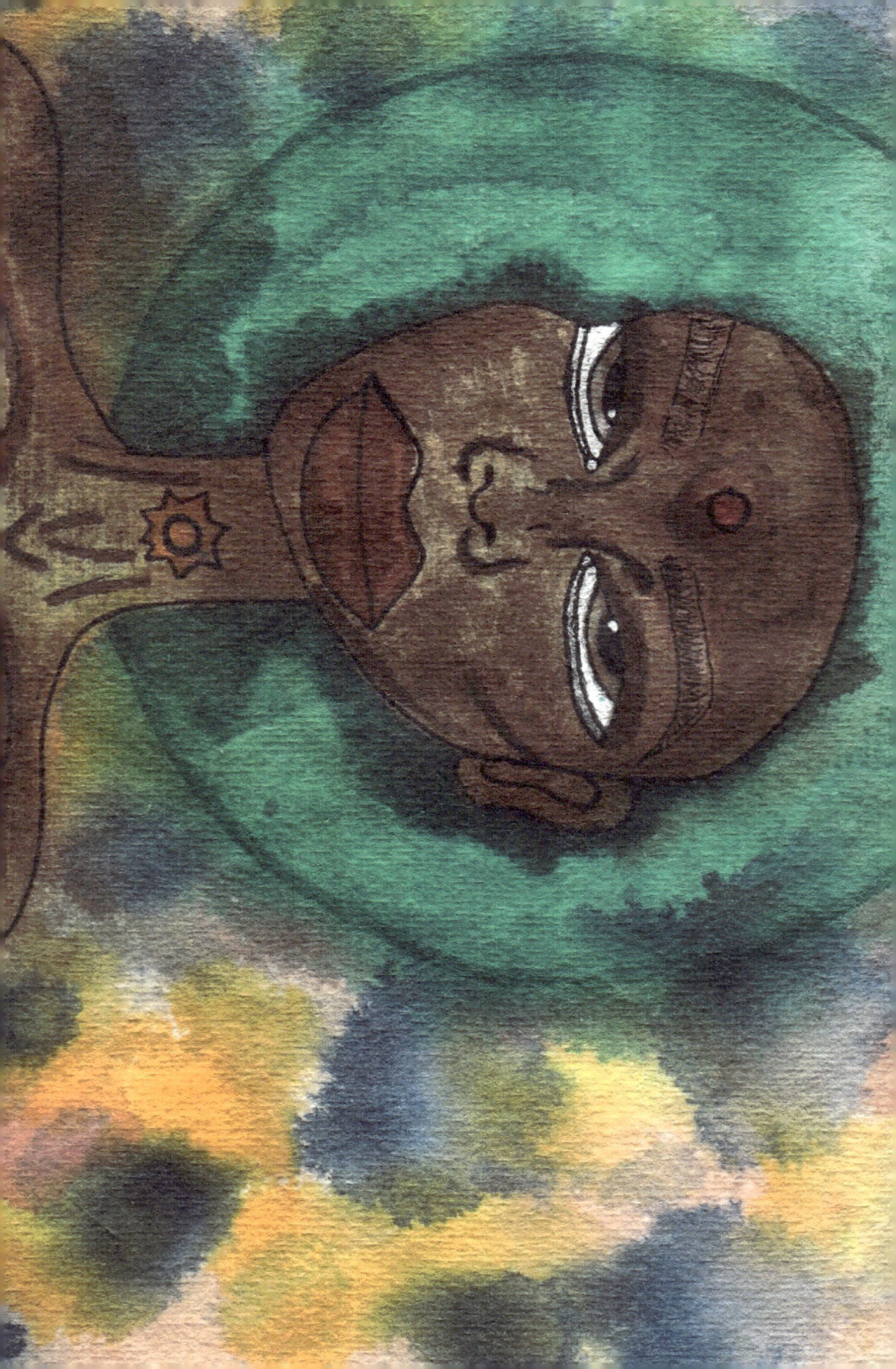

Today I found out I lost someone who I am close to. I am trying to be not selfish. I do not want to mourn because I will miss him, I want to mourn because he will miss his family. He still had so much art left in him. I admired his love for the color green and his love for his family. He taught me that MULAN is an important movie. The fun in being yourself, and not to apologize for it. Don't apologize for being happy, for being comfortable. He taught me to love as much and as hard as you can for the people that matter, do not love in your free time, do it all the time. Make time for love, for family. R.I.P TERRY ♥

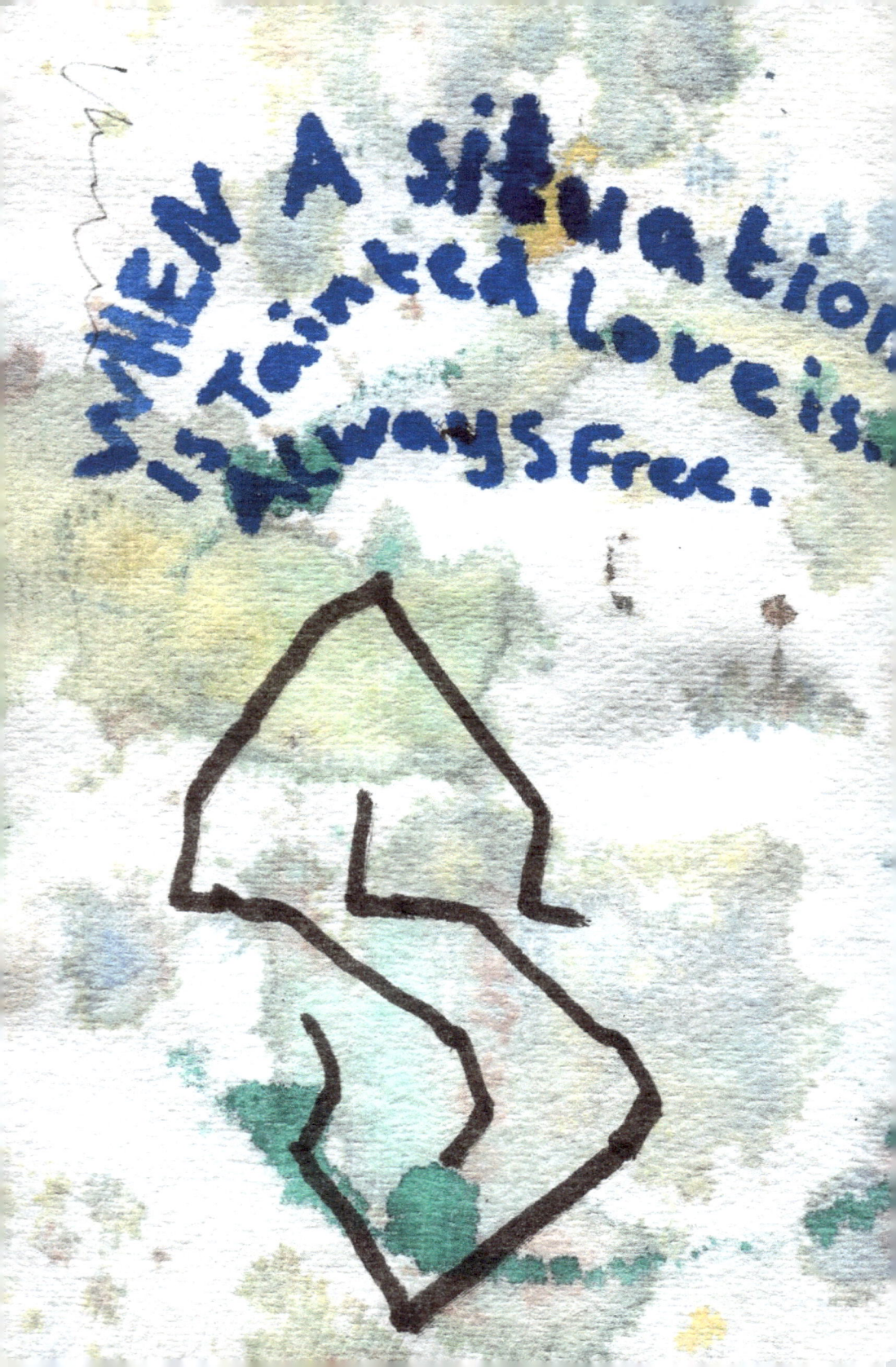

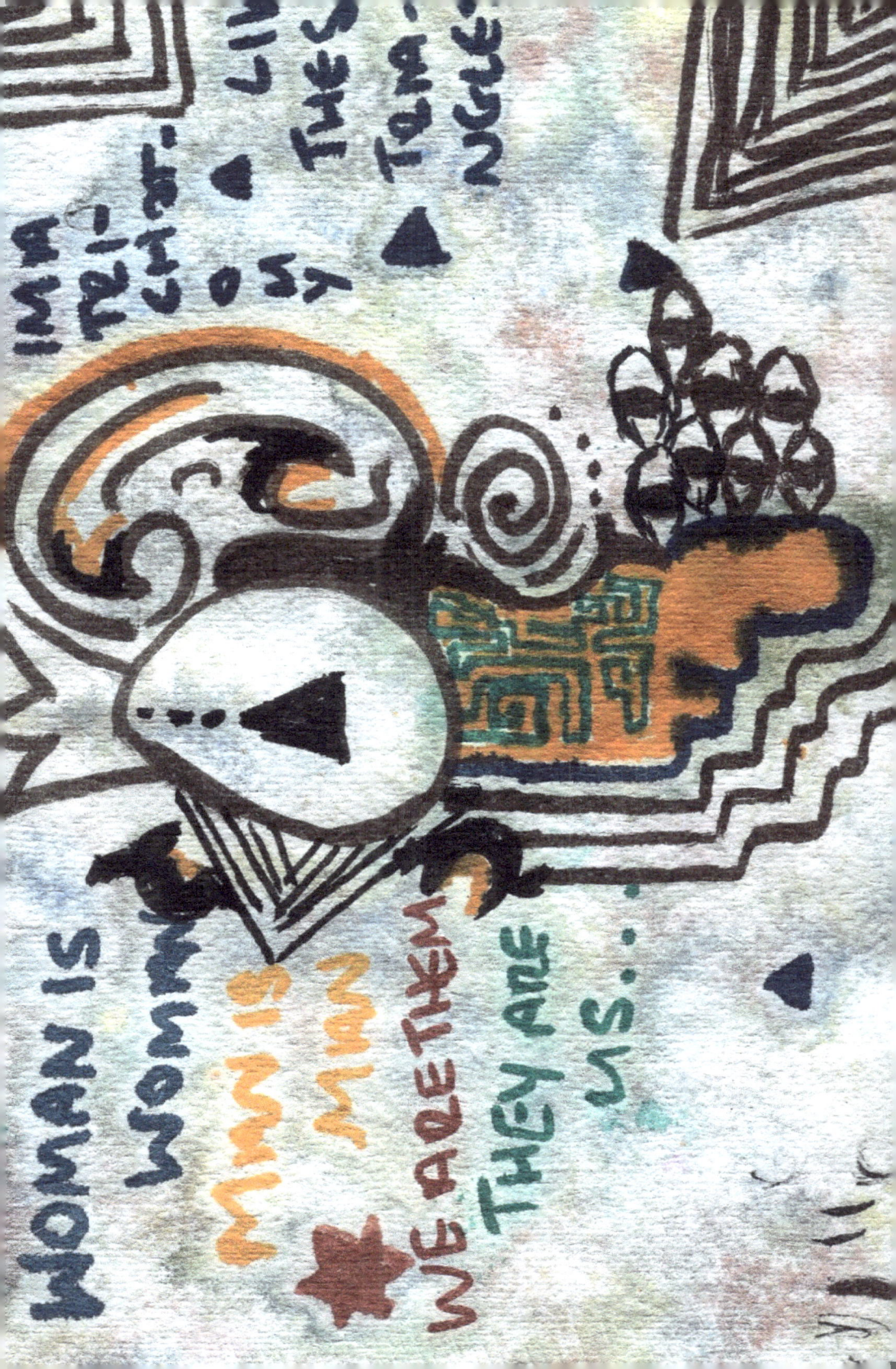

THIS IS HOW YOU FREE ME. I STILL HAVE NOT SPOKEN TO YOU. I WANT TO FORGET. WHERE DO I GO FROM HERE? EVERYONE IS LYING and EVERYBODY WANTS TO FUCK. IT'S A STRAGE GAME WE PLAY. BRING ME THE SUN

And I will burn all of this. The empty spaces reminds me of isolation and you; it lasts within you and it spreads further than you can imagine. And I swear to God, this is how I take myself back.

...IS HOW YOU LOVE ME.
...STILL HAVE NOT LIED TO
... I WANT ~~TO BE LOVED~~
~~ACK~~ TO BE ~~S~~ CONSIDERED
~~RE~~ SACRED. WHERE DO I
...FROM HERE? EVERYONE IS
~~JUDGEMENTAL~~ THINKING
...BOUT THEMSELVES. AND
...VERYBODY ~~LIES TO US~~
~~LIES TO EACHOTHER HAS BAD~~
~~ENTIONS~~ WANTS TO ~~BE LOVED~~.
... A STRAGE GAME WE PLAY.
...ING ME THE SUN AND I WILL
~~POSE HEAL DESTROY~~ CHANGE.
...L OF THIS. THE EMPTY
...ACES REMINDS ME OF HIDDEN
...UTHS AND GOD; IT
...STS WITHIN YOU AND IT
...READS FURTHER THAN YOU
...N IMAGINE. AND I SWEAR
...GOD, THIS IS HOW I
...KE MYSELF BACK.

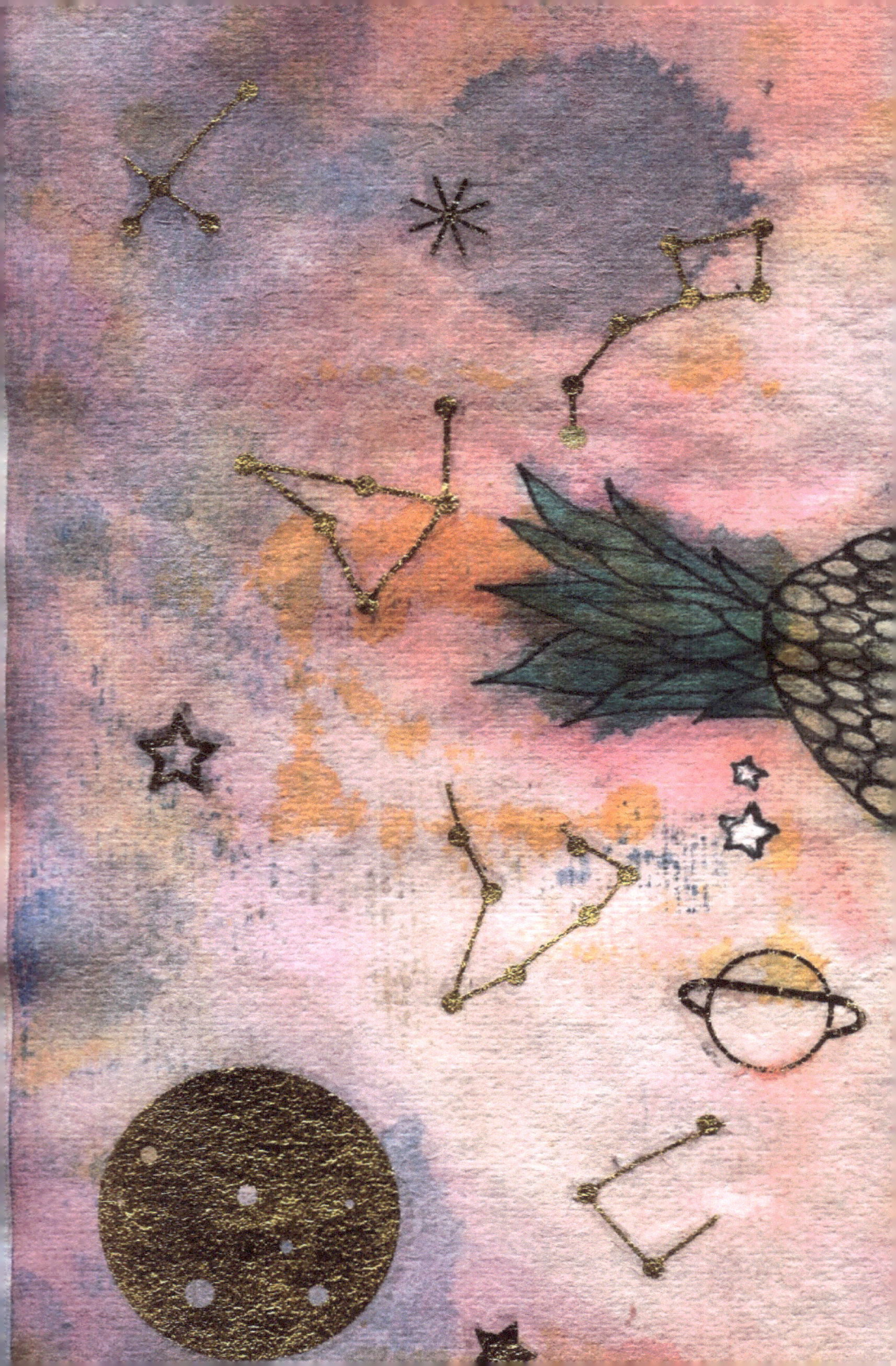

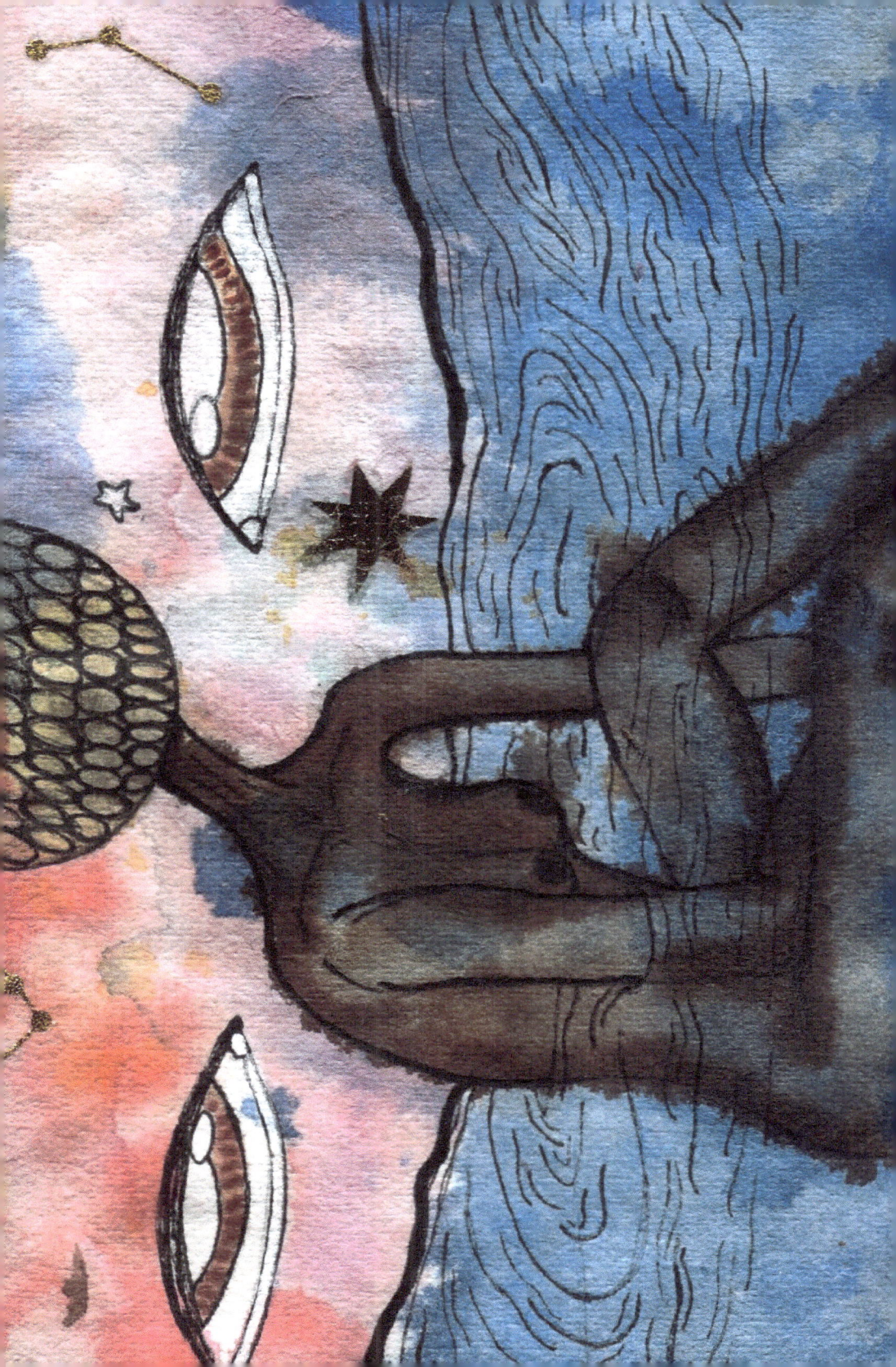

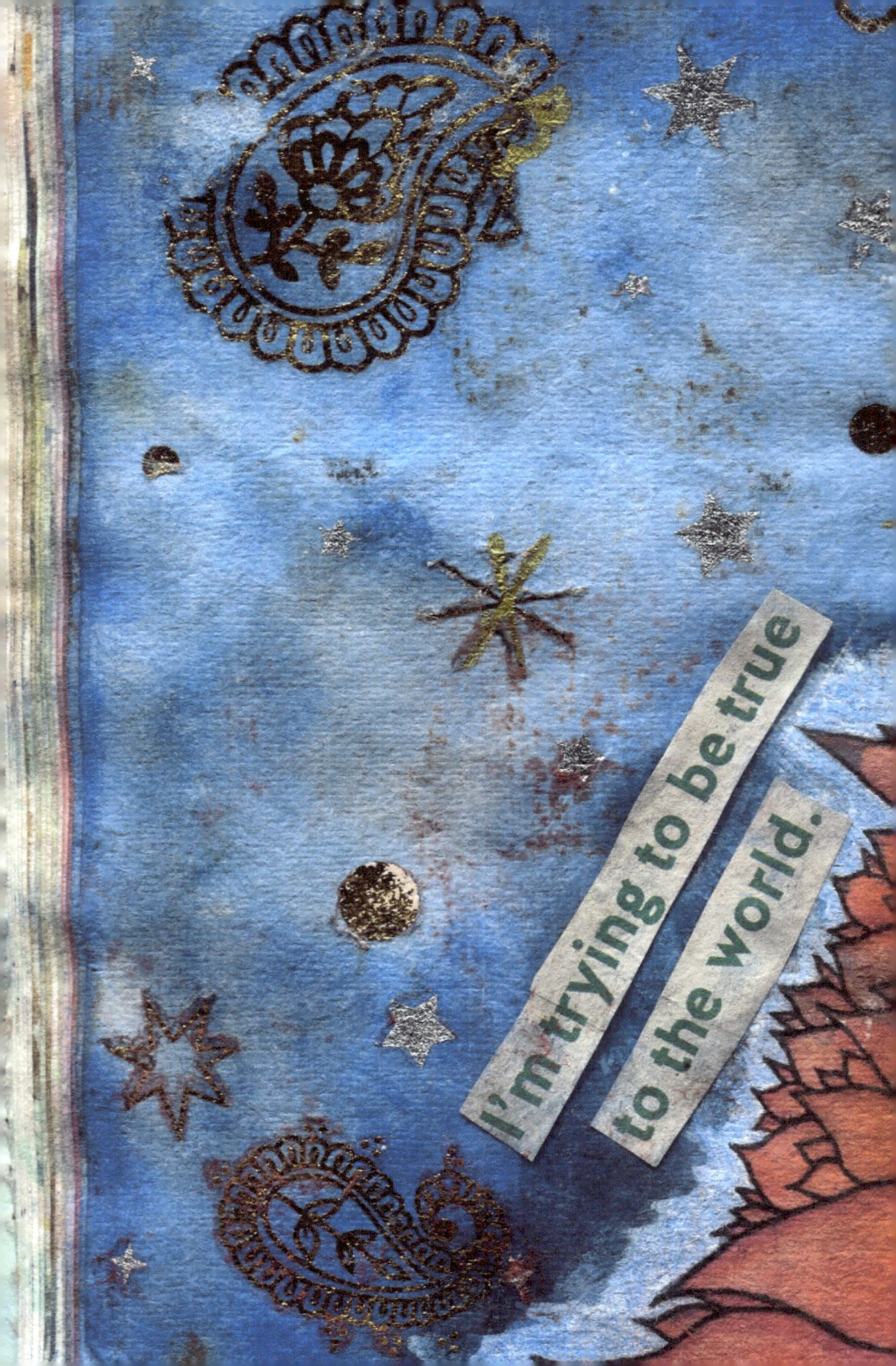

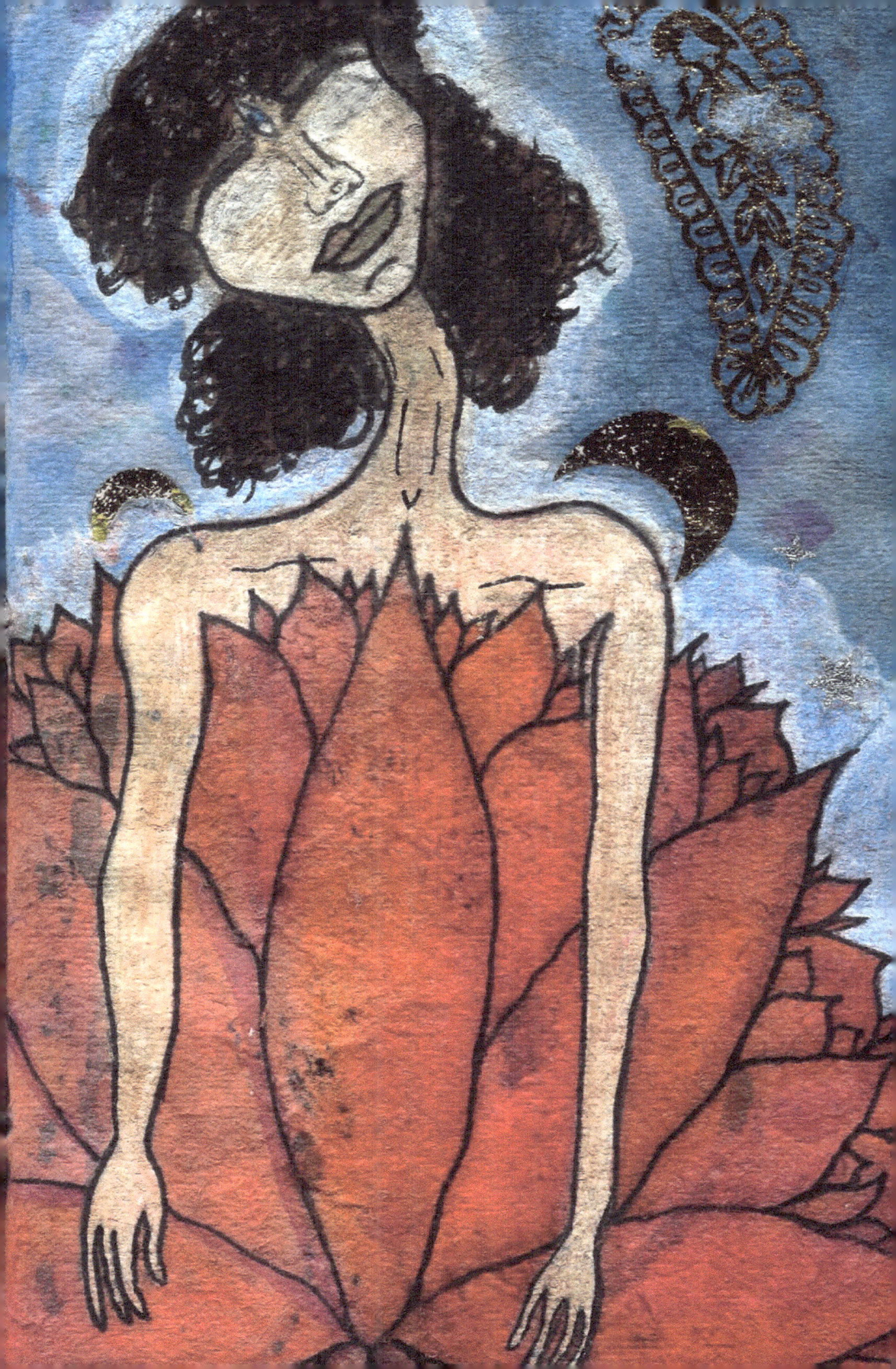

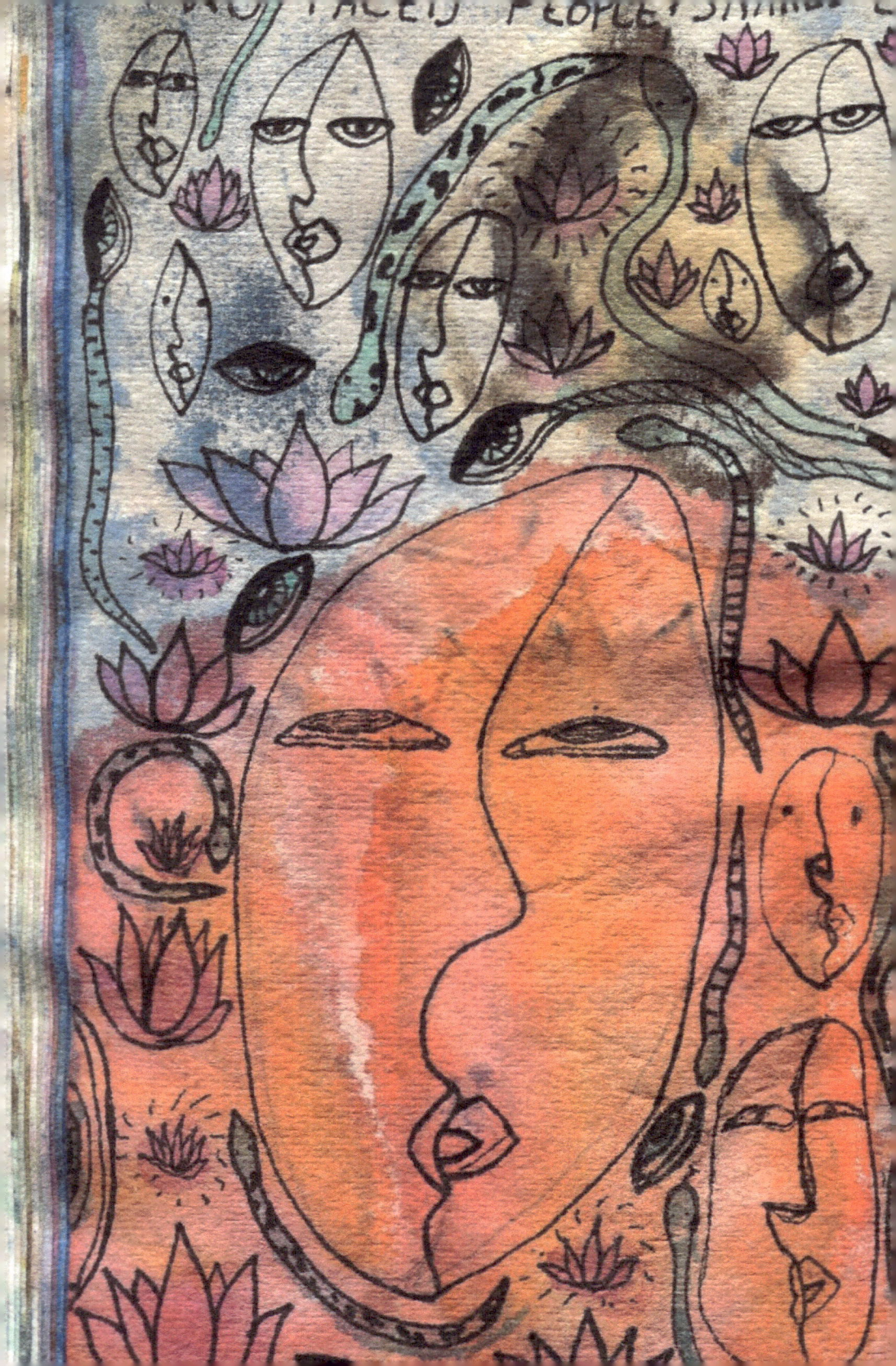

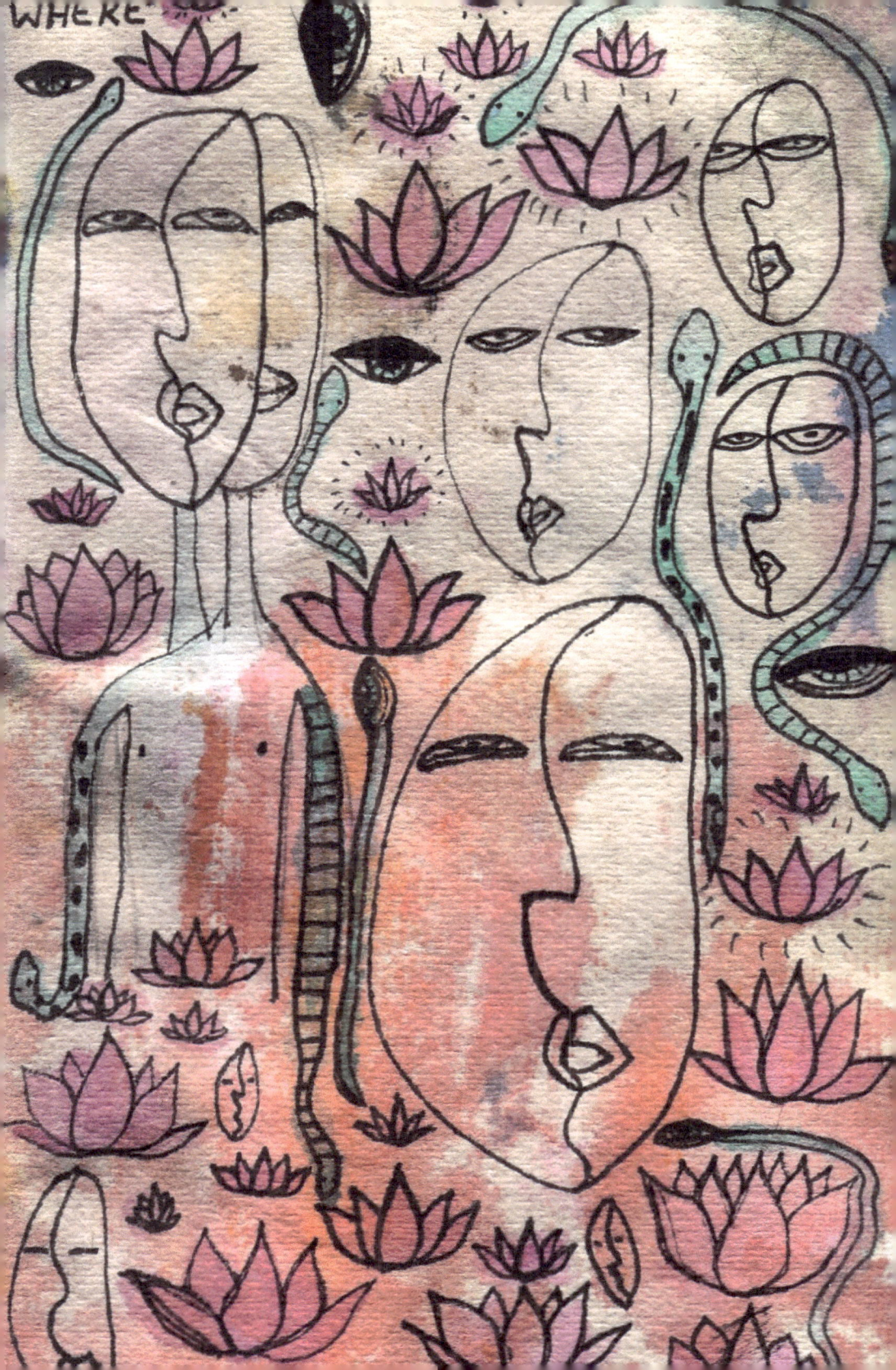

genuine your intentions. Run it now, why are you here now, why are you so eager, self righteous, or misdirected? Are you holding yourself accountable? First are the consequences of your actions? Are your feelings and facts consistent with an argument for your actions? Do you have sometimes you love-to see others fail? What does toxic mean to you? Is your way of thinking damaging or enriching? This conversation is about the illness and critical reasons why we are here, why we are touring another's autonomy and holding you accountable for real any reasons

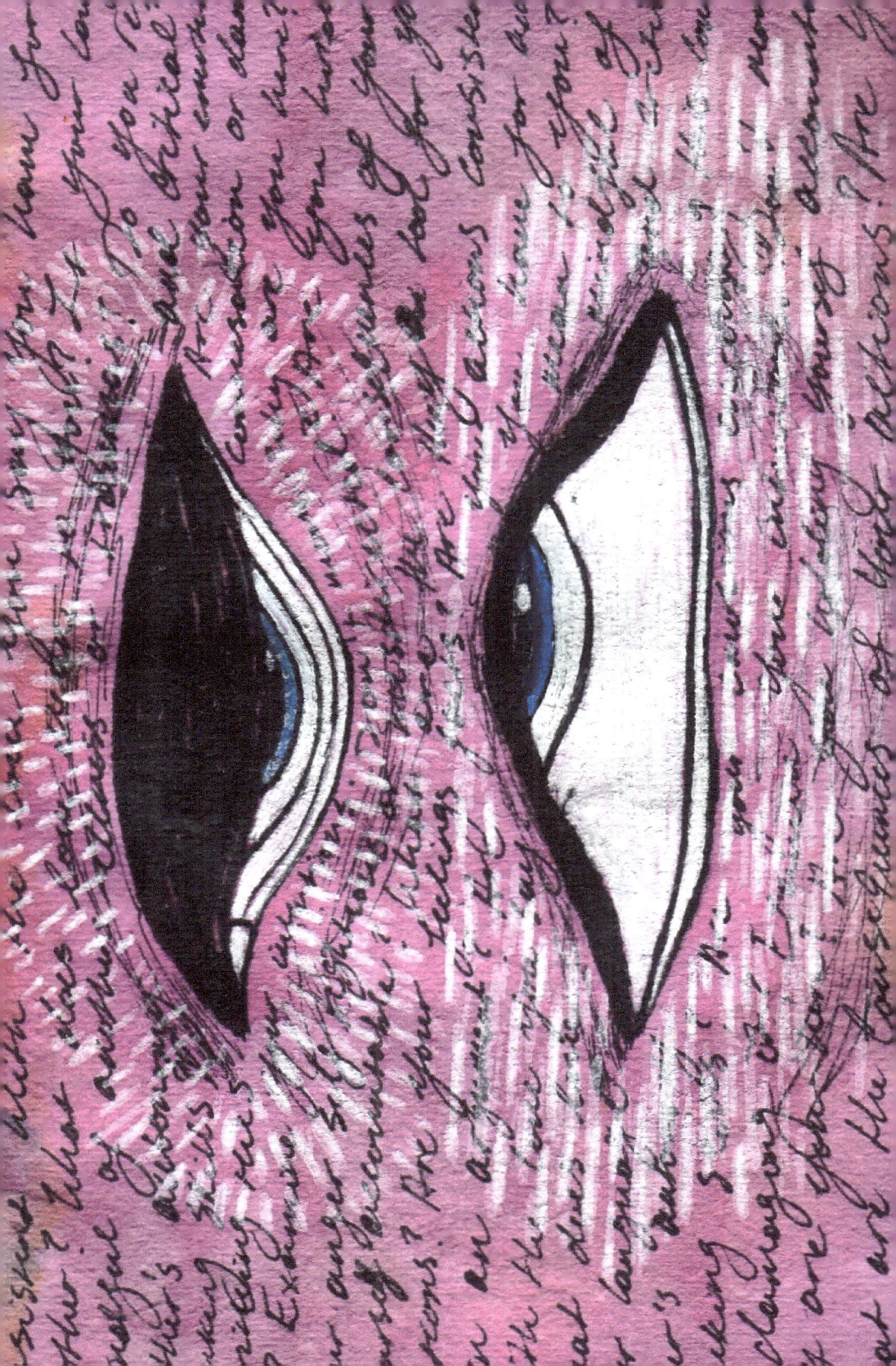

Je t'aime

You got yourself neither me
for pushing too long. But
baby I've been patient
all year. I know your
strong. Maybe just in
different ways than I
am. Don't lie to me,
tell me you plan to
make me your home. I
forgive you and I
want you to be free
of any need to be tied
down. If you don't
want to grow then I
forgive you but don't
expect me to want you
home. Paris is opened

I let you in

FOCUS

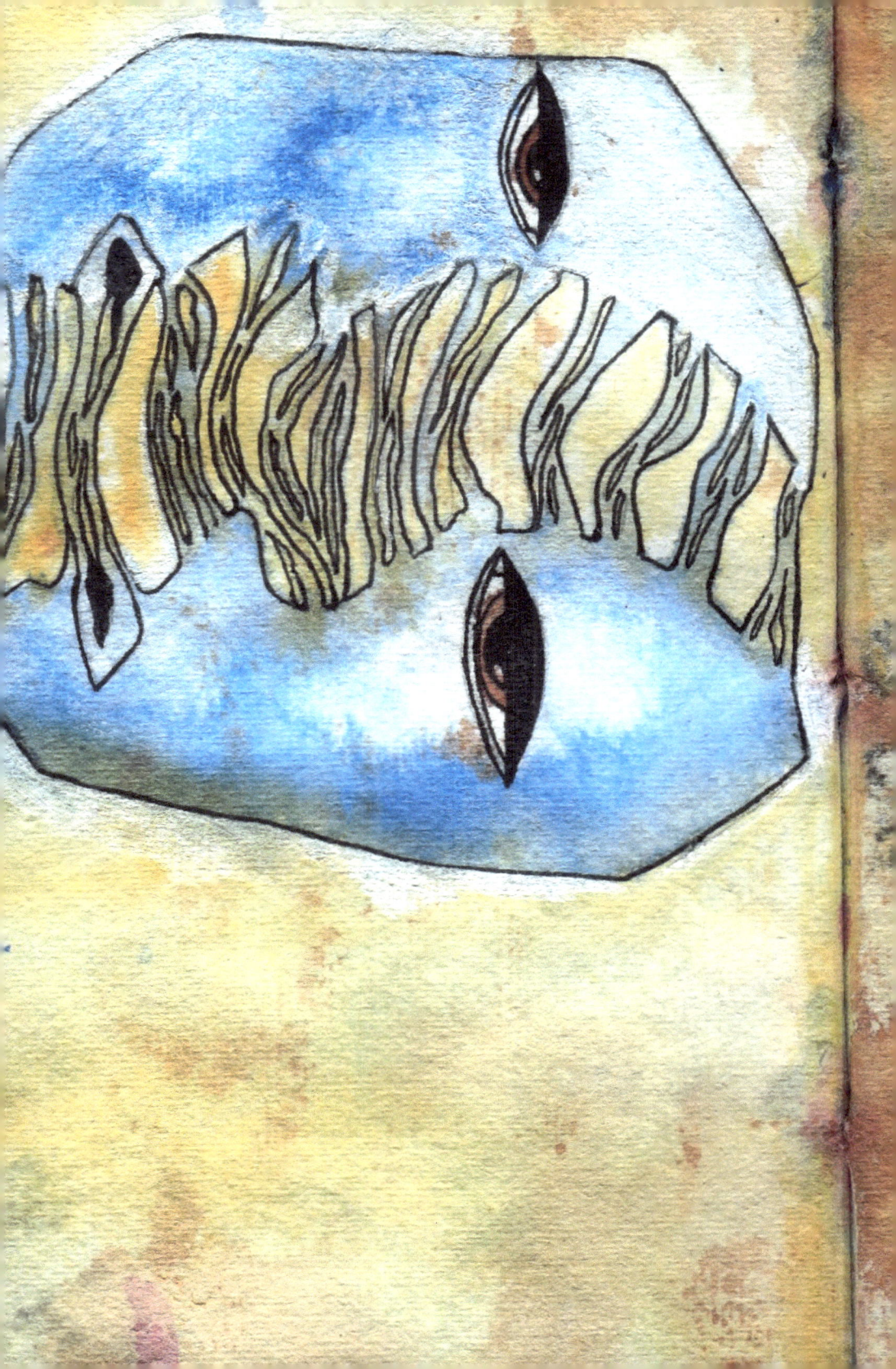

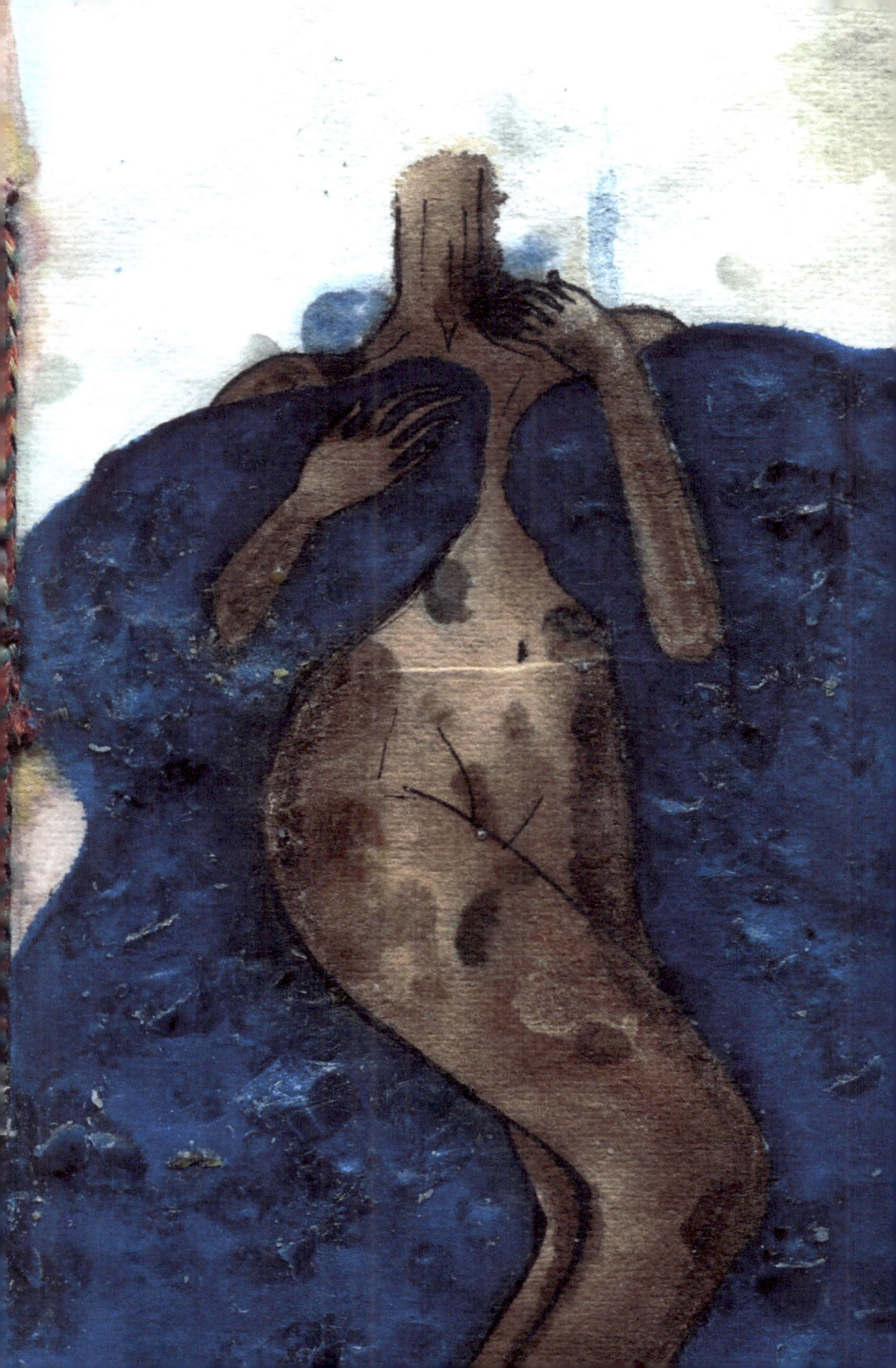

www.ingramcontent.com/pod-product-compliance
Lightning Source LLC
Chambersburg PA
CBHW041206180526
45172CB00006B/1207